EGON WEINER
PILLAR OF HUMAN EMOTIONS

July 10 - September 19, 2014

KOEHNLINE MUSEUM OF ART

INTRODUCTION

*E*gon Weiner: Pillar of Human Emotions is another exhibition in a series at the Koehnline Museum of Art examining Chicago artists through a new perspective. In the last decade, the museum has produced historical exhibitions featuring Chicago artists such as Gregory Orloff (2009), Morris Topchevsky (2012), and Leon and Sadie Garland (2013). In 2001, the Koehnline coordinated a major exhibition on renowned Chicago artist Richard Hunt, one of Weiner's students at the School of the Art Institute of Chicago (SAIC). While all the above-mentioned artists were *students* at the SAIC, Weiner *taught* at this school for 26 years, and had a significant impact on many artists, particularly sculptors.

Weiner is representative of many post-war American artists who escaped the Nazi occupation during World War II and immigrated to the United States to re-start their lives and careers with a refreshing energy. Although he lost his parents and one of his brothers during the war, the artist was filled with optimism—as symbolized in his best-known monumental sculpture, *Pillar of Fire*, which illustrated revival after destruction. Weiner was passionately committed to art. As he wrote in his book *Art and Human Emotions*: "The artist is one who cannot live without art; as a human being he cannot live without love. All existing life is yearning for love, therefore let us observe the emotions which create art and art which creates emotions."

This is the second time I have had the privilege of discovering a major forgotten collection of a Chicago artist. In 2000, I found a large body of works by Topchevsky at his brother's basement-studio in Skokie. Four years ago, the Koehnline Museum received two sculptures by Weiner (*The Reaper* and *Troll*) as a gift from Herbert Wolf and his family in memory of his wife and their mother Nancy Bild Wolf (1929-2012). The two sculptures stood in their Glencoe garden for more than 20 years. After accepting these pieces, I started researching Weiner's career and tracking more of his work, besides his well-known outdoor sculptures. Two years ago, I met sculptor Joseph

Burlini, who told me that he had known Weiner when he (Burlini) was a student at the SAIC in the late 1950s. To my surprise, he also revealed that there was a large collection of Weiner's sculptures at the Bucthel Metal Finishing Corporation factory in Elk Grove Village. Upon arrival at the factory, I learned from its owner, Abe Yousif, that these sculptures—part of the artist's estate—are temporarily in his possession at the request of the artist's son, Andrew Weiner. The stored collection consists of more than 20 small size sculptures and Weiner's last large piece, *Moon Flower*. Most are featured in this exhibition, in addition to the two pieces from the museum's permanent collection and photographic documentation of the artist's major outdoor monuments.

I would like to thank the individuals and institutions who contributed to the success of this exhibition, including the artist's son, Andrew, and his wife, Stephanie, for lending us the sculptures and providing essential documents and photos; Abe Yousif of Bucthel Metal Finishing for his generous assistance with Weiner's estate collection; Alicja Zelazko for her comprehensive research at the School of the Art Institute of Chicago archive; Herbert Wolf and his family for the gift of two of Weiner's sculptures; sculptors Richard Hunt and Joseph Burlini for their interviews, sharing their recollections on Weiner the teacher; Anthony R. Stetina for photographing Weiner's estate collection and his outdoor sculptures; Oakton photography lecturer Jeremi Bialowas for image editing; student assistants Amanda Watkins and Piotr Chmielewski for their assistance in research and preparation for this exhibition; Jesse Wallace, Oakton's media services video engineer, for producing the video for this exhibition; the School of the Art Institute of Chicago archive, University of Wisconsin — Milwaukee, the Langenzersdorf Museum in Austria, and the Standard Club of Chicago for documents, images, and permissions; and the Illinois Arts Council, a state agency, for partially funding this program.

Nathan Harpaz, Ph.D.
Manager and Curator, Koehnline Museum of Art

EARLY CAREER: VIENNA

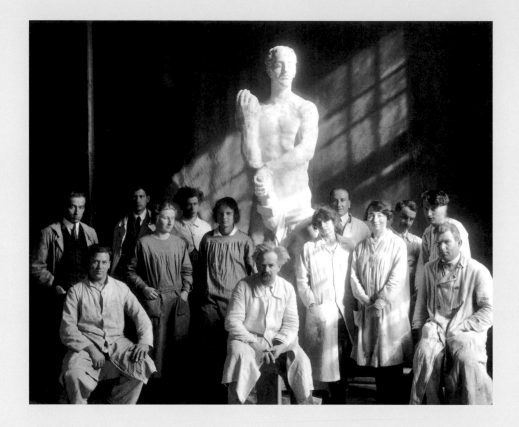

Fig. 2. Anton Hanak (first row, center)
with students, including Egon Weiner
(back row, third from left), Vienna,
late 1920s. Photo courtesy of the
Langenzersdorf Museum, Austria,
Hanak-Archive.

Egon Weiner (1906-1987) began his artistic career at the age of 14 when he started working at the Vienna studio of woodcarver Karl Eisenfest in 1920. Through 1924, he produced different ornaments and compositions in wood at the studio, including a romantic altar for a church. At the same time, Weiner also attended the Professional Industrial School, graduating with honors in 1924. His early experience with woodcarving would be noticeable later in the large body of wooden sculptures he created throughout his career.[1]

Between 1924 and 1927, Weiner studied at Vienna's School of Arts and Crafts. One of his teachers there was Eugene Steinhof (1880-1952), a Viennese architect, painter, sculptor, and structural engineer who was a student of Austrian architects Otto Wagner (1841-1918) and Josef Hoffmann (1870-1956), French artist Henri Matisse (1869-1954), and German sculptor Adolf von Hildebrand (1847-1921). Steinhof, the school's director between 1923 and 1930, enriched it by his association with iconic figures such as architects Le Corbusier (1887-1965), Walter Gropius (1883-1969), Mies van Der Rohe (1886-1969), Frank Lloyd Wright (1867-1959), Erich Mendelsohn (1887-1953), André Luçart (1894-1970), and Henry van de Velde (1863-1957); composer and painter Arnold Schoenberg (1874-1951); composers Maurice Ravel (1875-1937) and Manuel de Falla (1876-1946); and physicist Albert Einstein (1879-1955).[2]

The interdisciplinary nature of the School of Arts and Crafts had a significant impact on Weiner's career with regard to the diverse artistic mediums that he managed and his understanding of the relationship between sculpture and architecture. Throughout his career, he used varied sculptural techniques such as ceramics, carving in wood and stone, and bronze casting—as well as contemporary methods such as aluminum casting and the application of found objects. Weiner's monumental outdoor sculptures were integrated with the architectural environment, and he designed stained or sandblasted glass windows for public buildings. His interest in architecture also was reflected in the sculpted portraits he created of architects such as Dankmar Adler, Louis Sullivan, and Frank Lloyd Wright.[3]

Another major artist and teacher Weiner encountered at the School of Arts and Crafts was Anton Hanak (1857-1934), one of the most influential Austrian sculptors of the early 20th century (figs 1-2). Hanak, like Steinhof, was a close friend of Josef Hoffmann, and also knew Viennese artist Gustav Klimt (1862-1918). Through his 20-year teaching career, Hanak mentored more than 150 students, including Austrian sculptors Jacob Adlhart (1898-1985), Heinz Leinfellner (1911-1974), Margarete Hanusch (1904-1993), Angela Stadtherr (1899-1983), Hilde Uray (1904-1990), and Fritz Wotruba (1907-1975).[4]

Fig. 1. Anton Hanak (first row, center) with students, including Egon Weiner (left of Hanak), Vienna, late 1920s.

Fig. 3. Anton Hanak in his studio in front of his sculpture *The Last Man* (today outside the Vienna History Museum), c. early 1920s. Photo courtesy of the Langenzersdorf Museum, Austria, Hanak-Archive.

Hanak was a student of sculptor Edmund von Hellmer (1850-1935), one of the founders of the Vienna Secession and a dean in Vienna's Academy of Fine Arts. Hanak's early sculptures were academic in nature, but gradually moved toward symbolism and expressionism (fig. 3). Weiner's early works were inspired by Hanak, and his style similarly evolved from traditional to expressionistic to pure abstraction.

At the School of Arts and Crafts, Weiner worked in stone, wood, and terracotta. While a drawing of a woman's torso (fig. 4) from that time demonstrates his skillfulness in academic rendering, his painted plaster sculpture of a pregnant woman takes a more archaic or primitive approach (fig. 5). A rare 1926 photo of Weiner's sculpture also reveals that he was experimenting with abstraction by turning a woman's torso into a geometric form (fig. 6). His exceptional talent was evident even as a student: Vienna's Technological Arts Museum exhibited one of his sculptures. Weiner also participated in the Vienna School of Arts and Crafts student section at the 1925 International Exhibition of Arts and Crafts in Paris—and won the Grand Prix.[5]

While Weiner attended the School of Arts and Crafts, he also studied music and took piano lessons at the Vienna Conservatory. His attraction to music was echoed later in the rhythm of his drawings and sculptures—particularly in his more abstract works. Like other modern artists in the early 20th century, Weiner searched for a link between music and visual art to achieve harmonic compositions via abstraction. A favorite painting—one that always hung in his home after the 1940s—was his pastel depicting a rainbow-colored woman playing a mandolin in a cubistic mode on a background of musical notes (fig. 7).

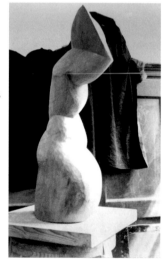

Fig. 6. Abstract torso at Egon Weiner's studio in Vienna, c. 1925.

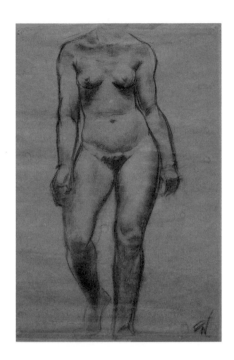

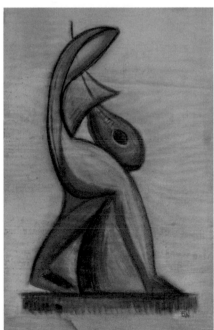

Fig. 4. Egon Weiner, *Nude Woman*,
c. 1924-25. Charcoal on paper, 17 x 12 in.

Fig. 7. Egon Weiner, *Woman with
Mandolin,* early 1940s. Pastel on
music notes paper, 17 x 11 in.

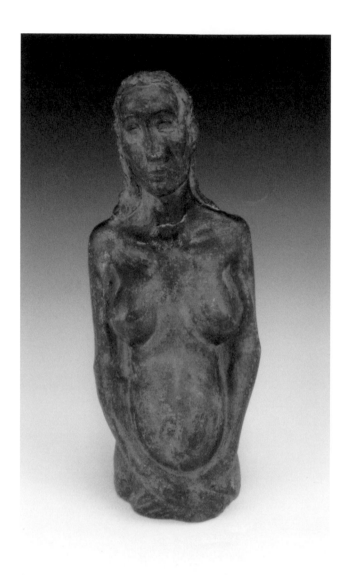

Fig. 5. Egon Weiner, *Pregnant Woman*,
c. 1924-25. Painted plaster, 14 x 5 x 4 in.

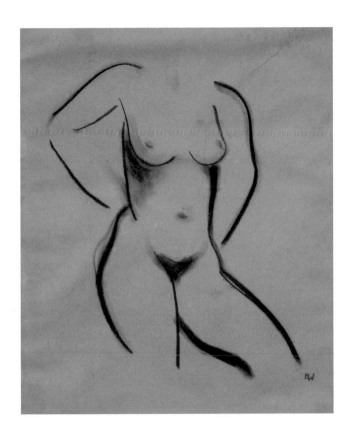

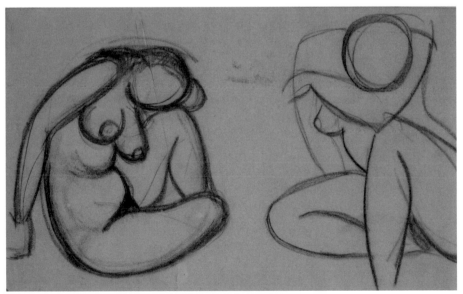

Fig. 11. Egon Weiner, *Nude Woman's Torso*, c. early 1930s. Chalk on paper, 20 x 14 in.

Fig. 12. Egon Weiner, *Two Nude Sitting Women*, c. early 1930s. Charcoal on paper, 10.5 x 16.5 in.

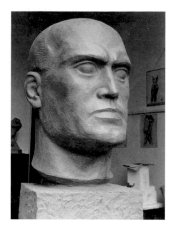

Fig. 8. Benito Mussolini's bust by Egon Weiner, 1929.

Fig. 10. Plaque of Austrian chancellor Dr. Johannes Schober in his birthplace, Perg by Egon Weiner, 1933.

Upon completing the School of Arts and Crafts in 1927, Weiner entered the Vienna Academy of Fine Arts on a scholarship. There, he studied under the Austrian sculptors Hans Bitterlich (1860-1949) and Josef Müllner (1879-1968) and again under Hanak. At the Academy, Weiner continued to excel and, in 1929, created a bust of Benito Mussolini in Rome, approved by a written statement from Mussolini himself (fig. 8). This work was produced during Weiner's first trip to Italy, and from 1929 to 1937 he vacationed there every year—often visiting Sicily as well—staying for two to three months to study art (fig. 9).[6] The depiction of the powerful Fascist leader by the young Weiner is an example of the artist's courage, curiosity, and unorthodox approach to art and politics.

During his later years at the Academy, Weiner continued to exhibit his works, especially portraits. In 1932, his busts of the German actress Lil Dagover and German actor Conrad Veidt appeared at the prestigious Vienna Künstlerhaus. That year, Weiner also received the Blumenthal Award for his work at the Academy, and a year later he displayed a bust of the British-American opera singer Alfred Piccaver at the iconic exhibition of the Secession in Vienna. In 1933, Weiner graduated from the Academy of Fine Arts with a written statement of approval from his beloved teacher Anton Hanak, who died a year later.

Weiner immediately established his studio in Vienna, and through 1938 was busy with commissions, exhibitions, and teaching. He also became a member of the Central Society of Austrian Artists and of the Vienna Art Community. In 1933, Weiner was commissioned to produce a plaque depicting the late Austrian Chancellor Johannes Schober in his birthplace Perg (fig. 10). A year later, he participated in a group exhibition at Vienna's Glass Palace; among other works, he displayed a bust of opera singer Leo Slezak and a plaque depicting the Austrian Chancellor Engelbert Dollfuss that was honored by a letter of appreciation and encouragement from Pope Pius XI. Early in 1933, Dollfuss shut down the Parliament and banned the Austrian Nazi party, but he was assassinated as part of a failed coup attempt by Nazi agents in 1934.

In 1935, Weiner returned to the Glass Palace and exhibited a second bust of Mussolini, a torso of a woman, and some portraits of children. The following year, he exhibited there again, displaying the bronze *Spear-thrower*, and won a medal

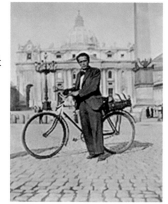

Fig. 9. Egon Weiner on a bicycle in front of Saint Peter's in Rome, c. 1930s.

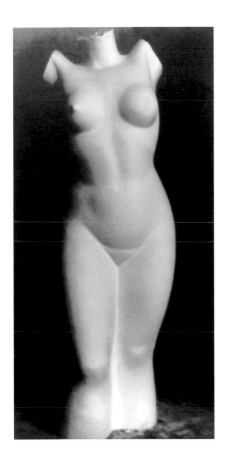

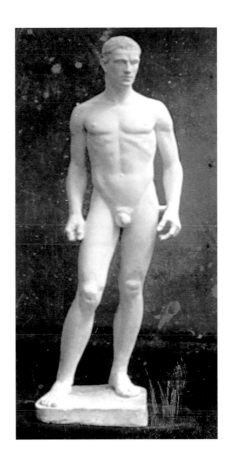

Fig. 13. Egon Weiner, *Woman Nude Torso*, c. early 1930s. Plaster.

Fig. 14. Egon Weiner, *Nude Man*, c. early 1930s. Plaster.

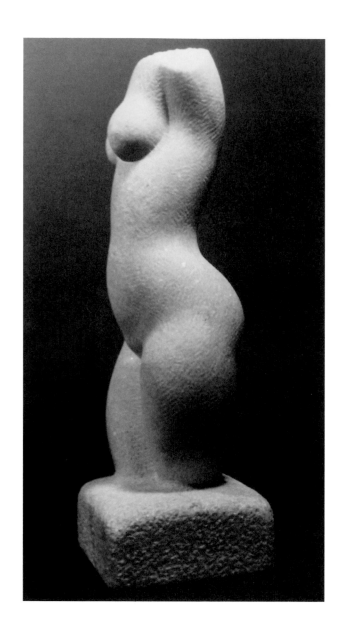

Fig. 15. Egon Weiner, *Woman
Nude Torso*, c. early 1930s. Stone.

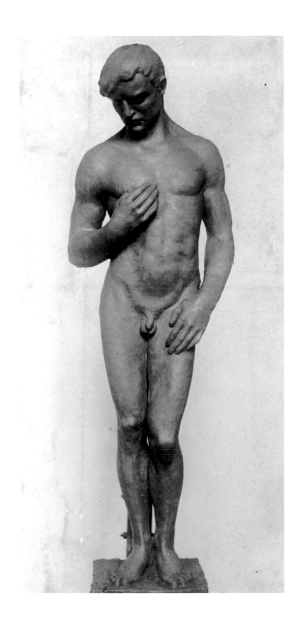

Fig. 16. Egon Weiner, *Adam*,
c. early 1930s. Plaster.

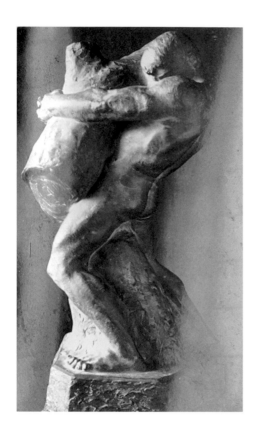 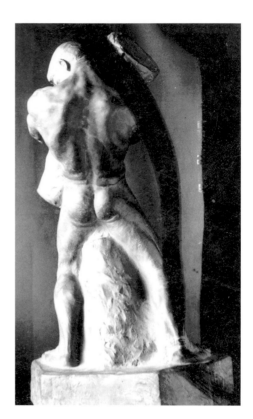

Figs. 19-20. Egon Weiner, *Slave*, Vienna, 1936.

of honor from the Vienna Society Against Cruelty to Animals for a statue symbolizing the Society's ideas. By 1936, Weiner was teaching art classes at the Public University of Vienna.

At this phase of his career, Weiner began moving toward a more personal artistic style, although some academic characteristics of his previous studies were still evident. In comparison with his early academic torso drawing (fig. 4), his new drawings of women's torsos reflected simplicity and a moderate touch of abstraction (figs. 11-12). While some of Weiner's sculptures at that time of transformation echoed classical values (figs. 13-14), others were inspired by ancient or primitive motifs (fig. 15). *Adam* (fig. 16) was treated formally as a classical composition, including the typical trunk of a tree that supports the sculpture. But the iconographical interpretation is whimsical and innovative: Adam touches and looks at his rib that, according to the Bible's Book of Genesis, was pulled out to create Eve. The torso of a pregnant woman (fig. 17) was inspired by the prehistoric fertility goddess figurine known as the *Venus of Willendorf* (Weiner certainly had access to this ancient piece, displayed at the Museum of Natural History in Vienna.) The pregnant woman's stomach and breasts are exaggerated; tiny hands cover her breasts, referencing breastfeeding.

In another sculpture, *Slave*, (figs. 18-20) Weiner creates a dramatic effect through the expressive gesture of the figure, whose muscles strain to their limit carrying a massive piece of a tree's trunk. Weiner references Michelangelo's *Bound Slave* in his despairing attempt to free himself from the block of the stone. *Slave* is also a reminiscent of Michelangelo's "unfinished" sculptures that were treated with different textures.

A striking example of Weiner's search for artistic self-expression is the sculpture *The Reaper*—a piece he experimented with in his studio around 1933. The artist produced two versions; each reflects a completely different artistic concept. One is a classical interpretation in full nude and idealistic proportions and expressions (fig. 21); the other is dressed and essentially realistic, although there has been some moderate elimination of detail (fig. 22). Both reference some elements of the ancient Greek sculpture the *Discus Thrower* (the specific moment and twisted gesture), but Weiner intentionally eliminated the

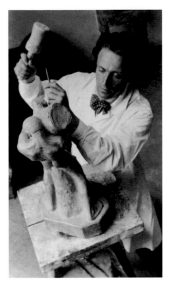
Fig. 18. Egon Weiner sculpting *Slave* in his studio, Vienna, 1936.

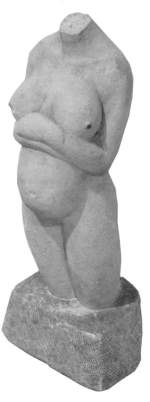
Fig. 17. Egon Weiner, *Pregnant Woman's Torso*, c. early 1930s. Plaster, 16 x 6 x 5 in.

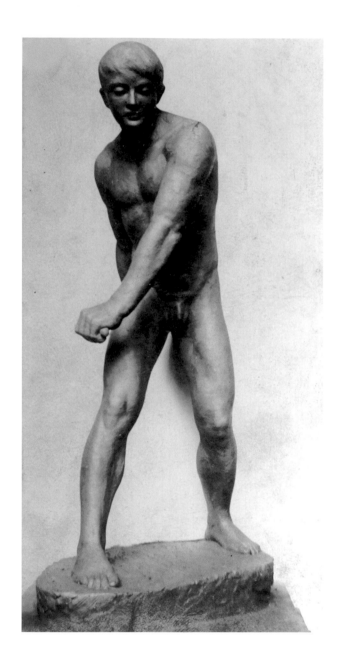

Fig. 21. Egon Weiner, *The Reaper,*
c. early 1930s. Plaster.

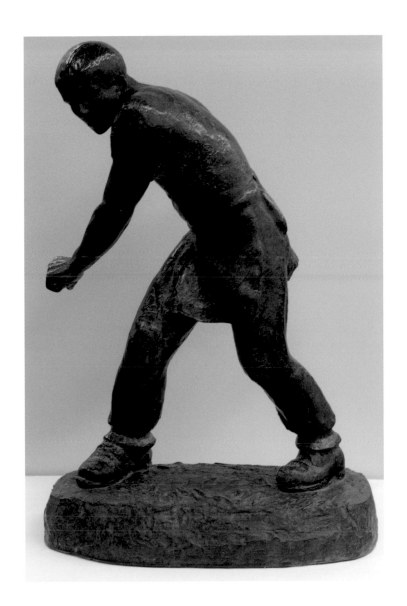

Fig. 22. Egon Weiner, *The Reaper*, 1933.
Bronze, 26 x 17 x 9.5 in. Collection of the
Koehnline Museum of Art. 2010.21. Gift in
memory of Nancy Bild Wolf (1929-2010)
from her husband and four children.
Wolf enjoyed this statue in her Glencoe,
Illinois garden for more than 20 years.

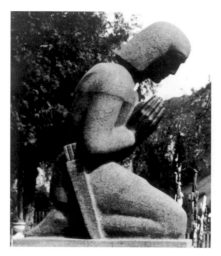

Fig. 23. Egon Weiner, monument for Ludwig Egger, the huntsman of the Austrian Emperor Franz Joseph I, 1935.

scythe in the reaper's hand, leaving it to the viewer's imagination. Deduction of elements in artistic compositions in early modern art was based on the psychological concept of "gestalt," which presumes that the viewers themselves will "complete" the piece by supplying a missing element from their own minds—as they are already familiar with the image from previous experiences. Weiner, who spent his early life in Vienna, a significant global center of modern psychology at that time, integrated this discipline into his art later in his career in Chicago. It is unclear if the artist means *The Reaper* to echo mythological or religious concepts of Death (Cronus or Grim Reaper), or to reference a social-realist expression of a laborer in the midst of an economic crisis.

In 1935, Weiner unveiled a monument honoring Ludwig Egger, the huntsman of the Austrian Emperor Franz Joseph I (fig. 23). The life-size,

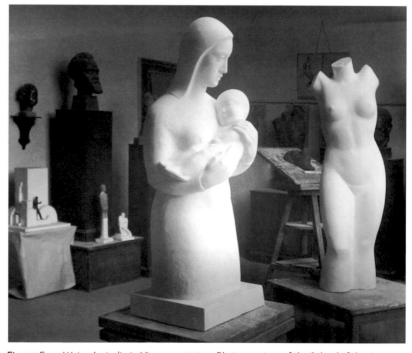

Fig. 24. Egon Weiner's studio in Vienna, c. 1936-37. Photo courtesy of the School of the Art Institute of Chicago archive.

cast-stone sculpture depicts Egger not as a typical hero, but as a kneeling and praying figure shaped in a medieval design. Many of the artist's future sculptures took a similar approach, highlighting human modesty and compassion whether they depict secular or religious figures.

A rare photo of Weiner's studio from around 1936-1937 (fig. 24) provides a unique glimpse into his artistic preferences just as he was establishing his career. In the background, on a black pedestal, is the bust of Weiner's beloved teacher Anton Hanak, and on the right one of his classical woman's torsos. In the center stands a monumental sculpture of mother and child that prefigures Weiner's later religious sculptures in its simplicity and human modesty. He adored this sculpture, and later, in Chicago, used its image on Christmas cards[7] (fig. 25). But for Weiner, it was not just a Madonna and Child, but a symbol of motherhood in general, including his own mother, whom he eventually left behind.

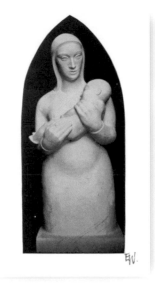

Fig. 25. *Mother and Child* on a Christmas greeting card sent to Roger Gilmore, provost of the School of the Art Institute, Chicago, 1981. Photo courtesy of the School of the Art Institute of Chicago Archive.

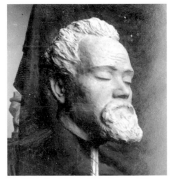

Fig. 26. Egon Weiner, Portrait Bust of Anton Hanak, 1936. Plaster.

In 1937, Weiner participated for the last time in the annual Glass Palace exhibition, concluding his short and brilliant career in Vienna. Because, as he noted, "My last works, all of heroic size (*Torso, Mother, Prophet*) did not have an opportunity to be exhibited,"[8] all of the sculptures on display unintentionally symbolized his initial career and ultimate departure from his birthplace: his bust of Hanak (fig. 26), *Slave* (fig. 18-20), and another work titled *Destiny*. On March 12, 1938, the Anschluss began when Nazi Germany annexed Austria. Weiner's mother was Christian, but his father was Jewish—and he wisely left Vienna after receiving a visa under the sponsorship of Albert Pick, owner of the Congress Hotel in Chicago. He never saw his parents and one of his brothers again: they all perished during World War II.

[1] Biographical notes by Egon Weiner, 1942, School of the Art Institute of Chicago archive.

[2] Steinhof, who moved to the United States in the early 1930s, had an influential role in architectural education. He was the author of *The History of Art and of Decoration in the Light of Psychology* (New York: New York Regional Art Council, 1932).

[3] Peter C. Merrill, *German Immigrant Artists in America* (Lanham, MD: Scarecrow Press, 1997), 285.

[4] Works by Anton Hanak and resources on the artist are in the Langenzersdorf Museum outside of Vienna.

[5] Biographical notes by Egon Weiner, 1942, School of the Art Institute of Chicago archive.

[6] Ibid.

[7] Weiner's Christmas card to Roger Gilmore, 1981, School of the Art Institute of Chicago archive.

[8] Biographical notes by Egon Weiner, 1942, School of the Art Institute of Chicago archive.

NEW BEGINNING IN CHICAGO

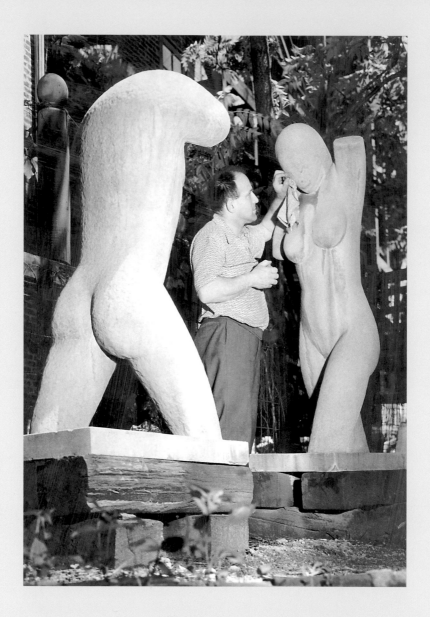

Fig. 41. Egon Weiner cleaning the sculptures *Adam* and *Eve* behind his home at 4761 Dorchester Avenue, July 1951. Courtesy of the *Chicago Sun-Times*.

n November 1938, Weiner arrived in Chicago, re-established his studio, started working on "compositions and portrait busts," and began teaching private classes.[9] In 1940, Weiner exhibited for the first time at the Art Institute of Chicago, presenting *The Reaper,* which he brought with him from Vienna (fig. 22), and two pieces he created in Chicago: *Ecce Homo* (1939) and *Torso* (1940).[10] *The Reaper* was suitably themed for the social-realist trend in American art during the Great Depression.

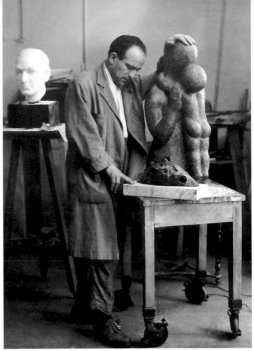

Fig. 32. Egon Weiner working on a stone sculpture of mother and child, c. 1950. Photo by Martin D. Koehle.

Weiner began participating in the *Annual Exhibitions by Artists of Chicago and Vicinity* at the Art Institute of Chicago in 1940, and in 1941 took part in the Pennsylvania Academy of Fine Art annual exhibition, where *The Reaper* was again on display. He also developed relationships with local art galleries, and in 1943 showed his work at the Pokrass Gallery with Chicago painter William Schwartz (1869-1977). A year later, Weiner was invited to participate in *Drawings by Contemporary Artists* at the Renaissance Society of the University of Chicago, and he returned there in 1945 for another exhibition: *Painting and Sculptures by Chicago Artists.*[11] According to the Renaissance Society's archive, the 1945 exhibition included Weiner's *Crouching Woman* (fig. 27, cast stone), *Head of a Child* (terracotta), *Leda* (terracotta), *Pieta* (painted plaster), *Portrait of a Lady* (painted plaster), *Standing Torso* (terracotta), and *Dr. Ulrich Middeldorf* (terracotta).[12]

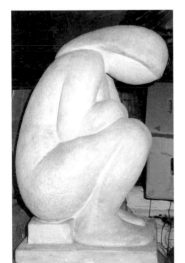

Fig. 27. Egon Weiner, *Crouching Woman,* c. 1940s. Cast stone.

The Middeldorf sculpture also appeared in the 1944 Art Institute of Chicago's *Annual Exhibitions by Artists of Chicago and Vicinity.*[13] Middeldorf (1901-1983), a renowned art historian who emigrated from Germany to Chicago in 1935 (three years before Weiner), was curator of sculpture at the Art Institute of Chicago during this time.

During the 1940s, Weiner continued with his artistic journey, still working with themes and styles developed in his Vienna studio. As always, he produced figurative sculptures, and many portrait busts reflecting his intellectual interests. Among the portraits are *Head of a Woman* made of wood (fig. 28), a terracotta of *Joan of Arc* (fig. 29), and a painted plaster *Head of Nietzsche* (fig. 30). Weiner was probably fascinated by the romantic

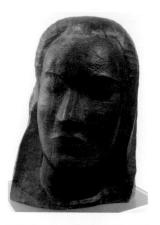

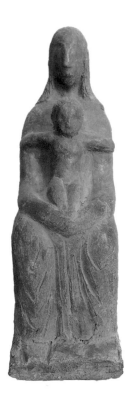

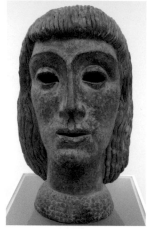

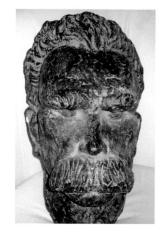

Clockwise from left:
Fig. 31. Egon Weiner, *Mother and Child*, c. 1940s. Terracotta, 12 x 4 x 5 in.

Fig. 28. Egon Weiner, *Head of a Woman*, c. early 1940s. Wood, 15 x 9 x 11 in.

Fig. 29. Egon Weiner, *Joan of Arc*, c. 1940s. Terracotta, 15 x 9 x 11 in.

Fig. 30. Egon Weiner, *Head of Nietzsche*, c. 1950s. Painted plaster, 15 x 7 x 10 in.

Fig. 33. Egon Weiner carving a wooden sculpture of a woman, October 1954.

image of Joan of Arc as a women heroine and martyr, and he certainly supported German philosopher Nietzsche's idea that the creative forces of the individual supersede any social, cultural, or moral values.

Weiner also returned to the motif of mother and child in the early 1940s. The small terracotta sculpture of mother and child (fig. 31) was designed in a similar, primitive manner as the small pregnant woman he created in Vienna (fig. 5). But thematically, the sculpture is completely different from the mother and child pictured in his Vienna studio (figs. 24-25). In the Viennese example, the mother is holding her infant child and looking at him in a more ordinary fashion. But the Chicago version is based on a religious statement of birth and re-birth: the passive mother stretches out her infant son's arms, presenting him as a standing crucified figure.

In the 1950s, Weiner started producing large-scale sculptures and outdoor commissioned pieces. From the small attic studio in his home on 4761 South Dorchester Avenue, he worked in variety of mediums, including stone (fig. 32) and wood (fig. 33). Weiner was still fascinated by the artistic possibilities of human torsos (fig. 34), but as evident in the small bronze woman's torso cast at that time, the rough texture and the gesture of the head indicate a more expressionistic mode (figs. 35-36).

Late in the 1950s, Weiner began eliminating details in his sculpted figures. The bronze *Sitting Couple* (fig. 37) depicts a young man and woman holding each other, their hands merged, creating the harmonic shape of a circle. The faces completely lack details, and the organic composition resembles the semi-abstract late 1950s sculptures of British artist Henry Moore (1898-1986).

Fig. 34. Egon Weiner holding terracotta of a woman's torso, 1956.

At the same time, the artist continued to depict well-known personalities, including Sigmund Freud (fig. 38). His attraction to Freud and modern psychology, all associated with his birthplace Vienna, intensified under the influence of his Viennese wife Margaret, a child

psychiatrist in Chicago. Other portraits by Weiner include writer Ernest Hemingway (fig. 39) and Martin Luther King, Jr. (fig. 40).

When Weiner displayed one of his nude cast stone sculptures, *Crouching Woman* (fig. 27), in front of his South Side home, his neighbors strongly disliked it. One placed a huge cardboard carton over the statue, and another left a note that read, "This neighborhood isn't up to such indecent art."[14] According to a reporter who covered the story for the *Chicago Sun-Times*, Weiner removed the carton and threw the note away, saying, "I am used to such goings on. An artist must expect opposition." It wasn't the first time his art had sparked this reaction. A similar controversy arose when Weiner displayed his two naked

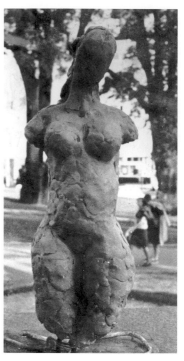

Fig. 35. Egon Weiner, *Female Torso*, c. 1950s. Clay.

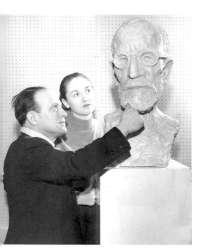

Fig. 38. Egon Weiner with his bust of Sigmund Freud at the Palmer House Galleries in Chicago, March 1956. Photo by Bob Kotalik, courtesy of the *Chicago Sun-Times*.

sculptures, *Adam* and *Eve*, in the backyard of his previous residence on 4847 South Lake Park Avenue. The statues, molded out of cement, sand, and gravel, were "beautiful to behold," according to Weiner, but their nudity offended prospective buyers. So he placed them in his backyard—visible to thousands of commuters passing daily on Illinois

Fig. 39. Egon Weiner, bust of Ernest Hemingway, c. 1960s.

Central trains. One angry passenger commented that "those statues are filthy," but another viewer thought that they were "lovely works." Weiner rejected the proposal of an Army colonel who lived nearby either to put pants on *Adam* or make certain changes. When he moved to the city's South Side, Weiner placed these pieces in his backyard "where they don't attract quite so much attention (fig. 41)."[15] But he exhibited *Adam* and *Eve* among several other sculptures at the Illinois Institute of Technology in Chicago in 1949.[16]

In 1954, Weiner completed the bronze *Brotherhood*, his first major public sculpture in Chicago (fig. 43), commissioned by the Union of the Amalgamated Meat-cutters and Butcher Workmen for its building on the northwest corner of Diversey Parkway and Sheridan Road.

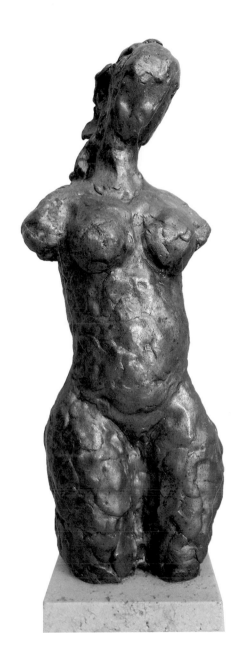

Fig. 36. Egon Weiner, *Female Torso*, c. 1950s. Bronze, 14 x 4 x 4 in.

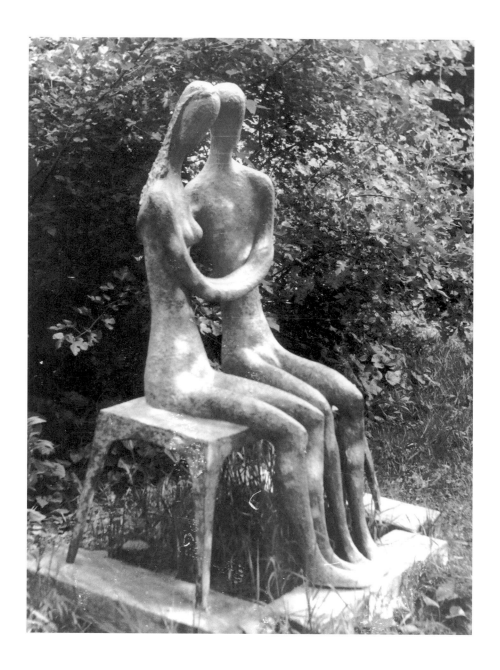

Fig. 37. Egon Weiner, *Sitting Couple*, 1957.
Bronze, 60 in. high.

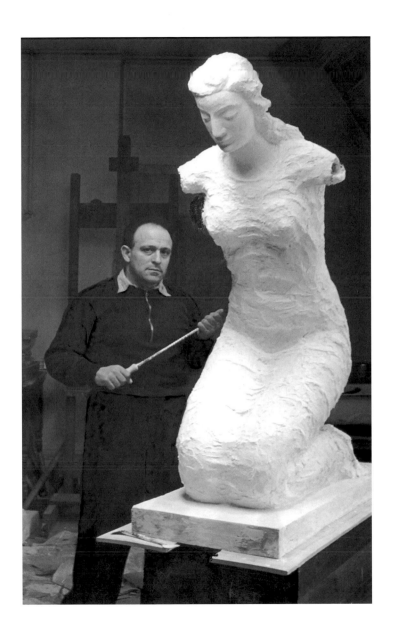

Fig. 50. Egon Weiner working on one
of the female figures for *Brotherhood*
in his studio, February 1953.
Courtesy of the *Chicago Sun-Times*.

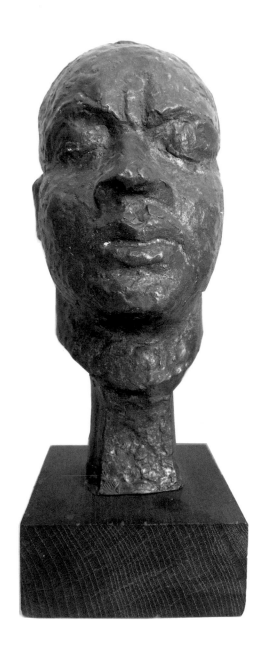

Fig. 40. Egon Weiner,
Martin Luther King Jr., c. 1960s.
Bronze, 14 x 5 x 6 in.

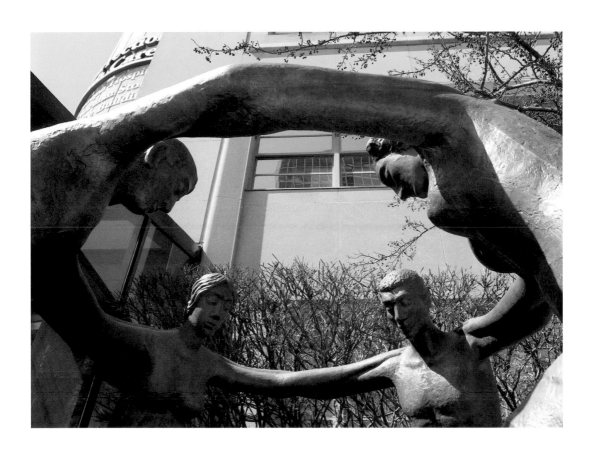

Fig. 48. Egon Weiner, *Brotherhood.*
Photo by Anthony R. Stetina.

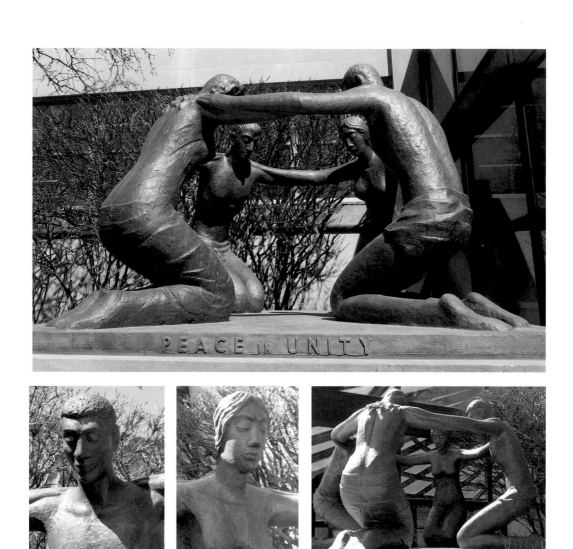

Figs. 44-47. Egon Weiner, *Brotherhood.*
Photos by Anthony R. Stetina.

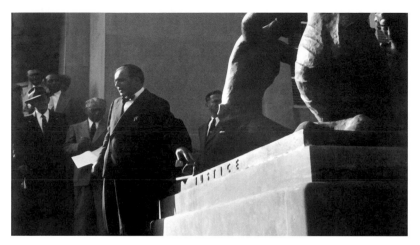

Fig. 43. Egon Weiner speaking during the dedication of his sculpture *Brotherhood*, 1954. Photo by Martin D. Koehler.

Fig. 53. Egon Weiner working on one of his male figures for *Brotherhood* at the foundry in Oslo, Norway.

Weiner placed two identical groups of four figures on either side of the building's entrance (figs. 44-45). "The kneeling figures, whose extended arms are intertwined," note Bach, Gray, and Molloy in their book *A Guide to Chicago's Public Sculpture*, "represent the unity of Europe, Asia, Africa, and North America."[17] The clearly different ethnicities reflected in the figures' faces convey the concept of a universal brotherhood, and the inclusion of two females and two males in each group promotes gender equality (figs. 46-47). The inscriptions around the figures echo this idealism: "Brotherhood," "Liberty," "Tolerance," and "Equality" appear on one group; "Peace and Unity," Justice," "Friendship," and "Knowledge" are on the other. The figures grasping each other compose a circle like the three mythological Graces holding hands and dancing in a circle to achieve harmony (fig. 48). "Their kneel-

Fig. 49. Anton Hanak in his studio, c. early 1920s. Courtesy of the Langenzersdorf Museum, Austria, Hanak-Archive.

ing posture," explains James Riedy in his book *Chicago Sculpture* "is intended to convey the surrender of individual ego, inherent in the concept of brotherhood."[18] Early in his Vienna career, Weiner created kneeling figures who were looking down (see fig. 23)—inspired by Hanak, many of whose own figures are leaning forward and looking down (fig. 49). Weiner sculpted the plasters of *Brotherhood* in his attic studio, and needed a special assistance to get them down and out to be transported to the foundry for bronze casting (figs. 51-52, page 34). In 1979, the Union moved its offices to Washington DC, and the

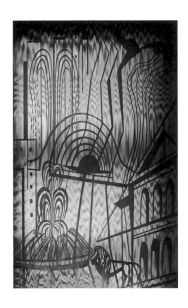

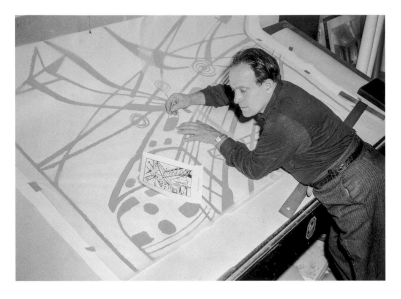

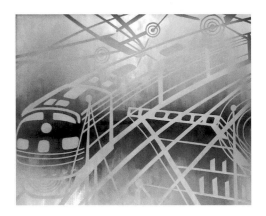

Fig. 54. Egon Weiner, *Art & Music* glass panel at the Standard Club building in downtown Chicago, 1957. Photo by Anthony R. Stetina.

Fig. 55. Egon Weiner sketching the *Transportation* window design for the Standard Club building in downtown Chicago, 1957.
Courtesy of the *Chicago Sun-Times*.

Fig. 56. Egon Weiner, the El-train, detail from the *Transportation* window, Standard Club building in downtown Chicago, 1957.
Photo by Anthony R. Stetina.

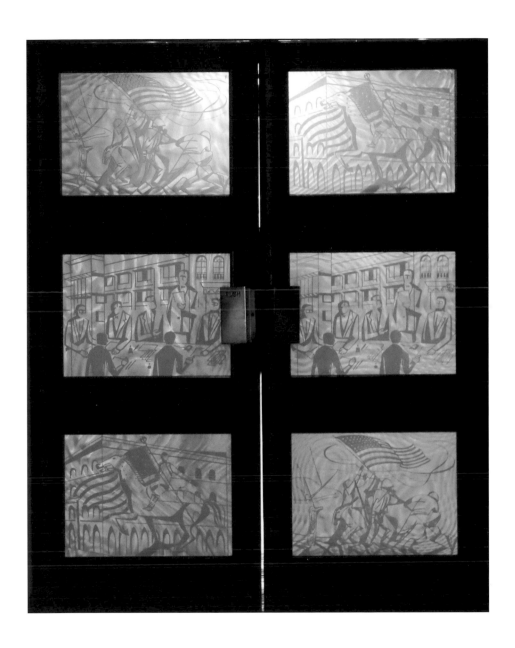

Fig. 57. Egon Weiner, Patriotic scenes
on the doors of the second floor
of the Standard Club building in
Chicago, 1957.
Photo by Anthony R. Stetina.

building was sold to St. Joseph Hospital. But the sculpture remains in place.

In the late 1950s, Weiner experimented with a new artistic technique: sandblasted glass. Applying a graphic design style, in 1957 he designed a series of glass window panels for the second floor of the Standard Club Building in downtown Chicago. Each has a specific theme: "Art and Music," "City Planning," "Science and Medicine," "Industry," "Transportation," and "Nuclear Research." In "Art and Music," Weiner depicts the Art Institute of Chicago, Buckingham Fountain, and the old band shell in Grant Park (fig. 54). "Transportation" features a dynamic, moving El-train (fig. 55-56).

Weiner also created the glass panel entry doors to that space, selecting two patriotic scenes: an image of a horse rider carrying the 13-star Betsy Ross flag from the American Revolution, and the well-known image of raising the flag on Iwo Jima in 1945 (fig. 57).

He also used sandblasted glass when he designed 12 windows at the Cedar Park Cemetery Chapel in Chicago in 1963. In this case, Weiner's graphic design elements were more abstract, including ornamental elements such as plants, a lamb, a star, a rose, and the Freemason symbol consisting of a square, a compass, and the letter "G" (figs. 58-61).

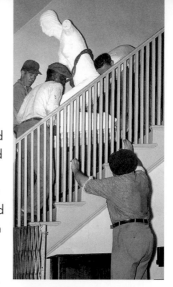

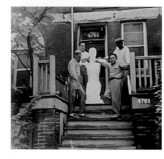

Figs. 51-52. Egon Weiner directing his helpers in moving the plasters of *Brotherhood* (top) and posing with one of the plasters at his home and studio on Chicago's South Side, 1953. Photos by Mildred Mead.

Figs. 58-59. Egon Weiner, details of fruit motif window (top) and Freemason symbol window, Cedar Park Cemetery Chapel.

[9] Ibid.

[10] From the *Chicago Sculptors* exhibition catalog, Art Institute of Chicago, July 18-October 20, 1940, p. 12.

[11] From a biography sent to the School of the Art Institute with the artist's request to teach at the school, June 3, 1945. School of the Art Institute of Chicago archive.

[12] *Painting and Sculpture by Chicago Artists,* The Renaissance Society at the University of Chicago, May 11 – June 6, 1945.

[13] From the Art Institute of Chicago's catalog for *Annual Exhibitions by Artists of Chicago and Vicinity,* January 27 – March 5, 1944, catalog no. 150.

[14] From an article in the *Chicago Sun-Times*, July 1, 1951.

[15] Ibid.

[16] Carol Glennie, "Students View Modern Art as sculptor Exhibits at Tech," *Technology News* (Chicago: IIT, December 2, 1949), 4.

[17] Ira J. Bach, Mary Lackritz Gray, and Mary Alice Molloy, *A Guide to Chicago's Public Sculpture* (Chicago: The University of Chicago Press, 1983), 176.

[18] James L. Riedy, *Chicago Sculpture* (Urbana: University of Illinois Press, 1981), 168.

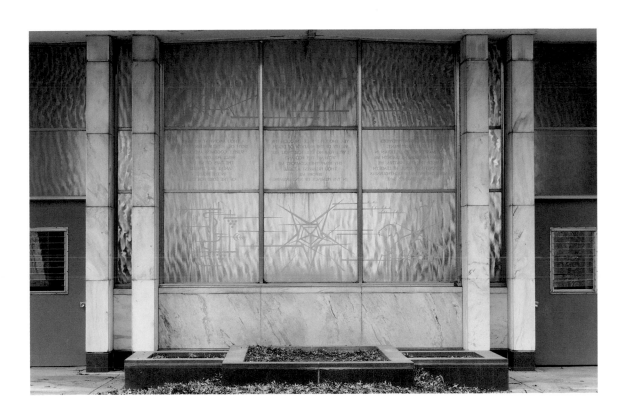

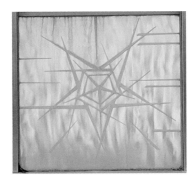

Fig. 60. Egon Weiner, sandblasted windows at the Cedar Park Cemetery Chapel in Chicago, 1963.

Fig. 61. Egon Weiner, detail of window, Cedar Park Cemetery Chapel. Photos by Anthony R. Stetina.

THE OBSESSIVE ENDEAVOR OF FRANK LLOYD WRIGHT'S BUST

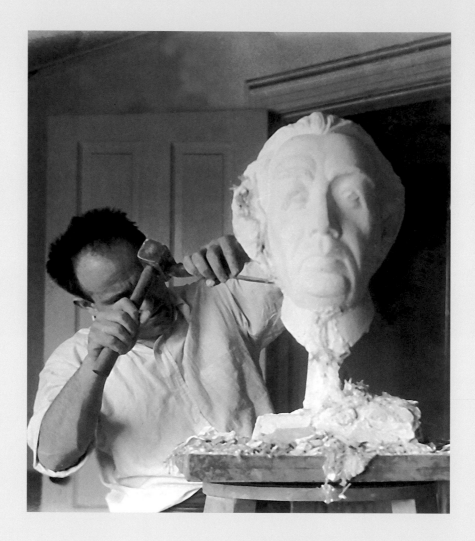

Fig. 62. Egon Weiner sculpting the plaster bust of Frank Lloyd Wright, c. late 1940s.

One of Weiner's most adventurous projects of the late 1940s was sculpting a bust of Frank Lloyd Wright. The artist encountered Wright for the first time in 1946 during a lecture the architect gave in Chicago. "The moment that Wright stepped onto the speaker's platform," recalled Weiner, "I knew what I wanted to be—had to be: the first person on earth to sculpt this man's head."[19] Weiner explained his attraction to the human form and, in particular, the human head by noting that it is "the most awe-inspiring sight on earth." And looking at Wright's head, he experienced "all the beauty and sorrow of a Beethoven symphony wrapped in one note or the poignant theme of a novel like *War and Peace* somehow compressed into a single word."

Weiner had pictures of Wright that had impressed him. "But nothing compared to encountering him in the flesh," he said. Weiner identified several qualities in Wright's face that he had never seen combined in one human countenance: the strength of the bone structure, the fact that the architect was a towering figure in spite of being a short man, the unchanging youth of his features even though he was 79 years old, the supreme peace in his eyes, and the soft-speaking mouth. Weiner summarized his psychological analytical observation of Wright's persona, saying, "So much gentleness fused to so much strength!" He came to the lecture to listen to Wright, but admitted that he heard nothing but his own "speeding thoughts as his eyes stayed magnetized upon the face of the lecturer." Weiner decided to sketch Wright's face by following him to lectures across the Midwest, capturing "the jaw, the eyes, the bones, the spirit." He was determined to ultimately build that face in bronze with his own two hands, and present it to Wright on the architect's 80th birthday (fig. 62).

Weiner didn't waste any time; during Wright's lecture he took his young son's bicycle repair receipt from his wallet and began working on the back with his pencil. His obsession was fueled by the idea that he would be the first artist to sculpt the prominent architect. Weiner was aware of the "thunderous force" in Wright's life, and his refusal to permit artists to sculpt his bust. He remembered that one of his friends from the Art Institute of Chicago had gone to Taliesin East, Wright's home and studio in Spring Green, Wisconsin, to ask the architect to pose for a painting. Weiner's friend, who had a great reputation as an artist, had been a guest of the Wright family several times before. But when the architect learned what his guest wanted, he was never again allowed past the front door. When the friend returned to Chicago he warned Weiner, "Never go near that man!"

Weiner noted that gaining entry to Wright's home was a more difficult challenge then any sculptural project he had ever undertaken, including the seven-ton, 30-foot *Pillar of Fire* that took him two years

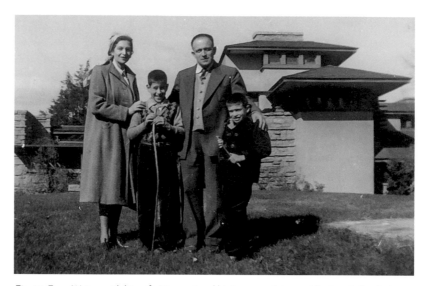

Fig. 63. Egon Weiner with his wife Margaret and his two sons Peter and Andrew in front of Wright's home and studio at Taliesin East, Spring Green, Wisconsin, c. late 1940s.

to finish. He completed a large number of sketches of Wright's head, but couldn't go further as he felt he must stand in front of the architect for the last critical touch. Weiner tried to find out when Wright would be at Taliesin East, knowing that every year shortly after Thanksgiving the architect left for his second home, Taliesin West, in Arizona. When some friends who had connections were unable to provide any information, Weiner became desperate. He decided to go to Wisconsin and try his luck after a woman he knew through the Art Institute of Chicago arranged a visit under one condition: he would have to pose as an architectural student. Weiner confessed, "I would have gone disguised as the milkman!"

Weiner took the train to Madison, where he was supposed to catch a bus to Spring Green. But "fate had conspired again" to stop him, as a storm had washed out a bridge the day before. Weiner decided to walk, carrying the 55-pound wood case containing the bust that he had already started to mold in his studio. The architect's home was 20 miles away, and after two and a half hours, the 40-year old Weiner almost quit—but suddenly Taliesin "sprung out of the landscape" and gave him "the heart to go on." When he finally got there, he faced a huge sign that declared, "Please respect the privacy of Mr. Wright." Ignoring the sign, Weiner knocked on the door, and after 15 minutes of "processing" by Wright's butler-bodyguard, was told to wait inside – the architect would be back in an hour. Weiner placed the bust on top of a grand piano in the corner of the den. While waiting, he started to play the piano and "was lost in the rather bombastic Turkish March of Mozart's Sonata in A Major with Variation," when he

suddenly heard a cane tapping impatiently against the floor and found the "stern-faced" Wright in the doorway.

Weiner looked at the architect, who stared back at him. Finally, Weiner gathered some courage and said, "I followed you to all but three of the lectures you gave since March, and I think I have virtually every picture of you ever taken, Mr. Wright. I wanted to present [this bust] to you on your 80th birthday. But I found I couldn't complete it without you." Wright moved his cane in a gesture of angry dismissal, but then his eyes fell on the sculpture and all at once his face softened. "That is a strong head," said Wright, "very strong." Then he paused, and continued, "One might enjoy having it around. Stay with us as long as you have to. I'll pose for you every day before the midday meal." And then he asked Weiner, "By the way, sculptor, how in the devil did you get here?" "I walked," replied Weiner. Wright pointed to the case and asked, "With that?" and Weiner answered, "I would have swum if it was necessary!" Wright pointed to his own jaw and said, "By the way, sculptor, was it exasperating working with this steel trap?"

Fig. 64. Egon Weiner's bust of Frank Lloyd Wright at the University of Chicago's Renaissance Society, March 1960. Courtesy of the *Chicago Sun-Times.*

Both laughed out loud and Weiner felt relief, recalling, "I was completely relaxed with Frank Lloyd Wright —even though he didn't know my name!"

Each day for a week, at 10:30 a.m., Wright and Weiner met in the den. The first time, Weiner found him sitting at the piano. He noticed that the dynamic power of Wright's head and neck seemed to course down into his hands and actually produce the music. Weiner liked that pose, as the architect was not just sitting—but was in the act of creation. "Yes, the incomparable ego the world had come to know was there, every minute of every day," remembered Weiner, "But as those days passed and as I returned to Taliesin through the years, I came to know another Frank Lloyd Wright" (fig. 63).

During the final sitting of Weiner's first visit, he asked Wright to assist him in molding a base for the sculpture (a crude wooden pipe in the bottom of the bust was serving as a stopgap measure). Wright sat down before the bust. He didn't say a word, but merely stayed there studying the work as Weiner timed him . . . an hour and 12 minutes. Then, Wright suddenly put his hands to it and began working, molding a stunningly original base without ever disturbing the pipe! "His home there in Wisconsin," noted Weiner, "is built around a tree in much the same way."

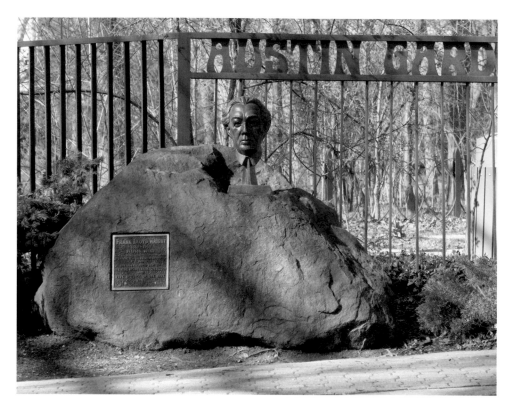

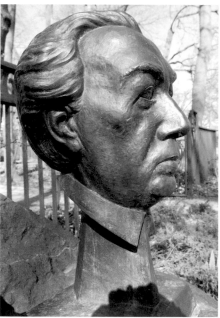

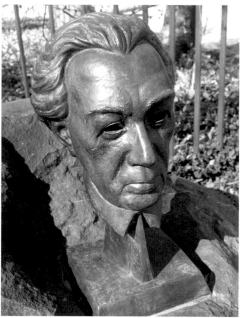

Figs. 65-67. Egon Weiner's bust of
Frank Lloyd Wright at Austin Gardens
in Oak Park, Illinois.
Photos by Anthony R. Stetina.

Weiner was impressed by Wright's "ocean-deep understanding of nature" and his awareness of the inevitable passage of time. He remembered his last visit with Wright, "who etched" Weiner's career "in gold" by allowing him to sculpt his face and letting him know "the mind behind that face." During that last visit early in 1959, Wright talked for a few minutes in the usual fashion and then rose abruptly, saying: "I must go back to work, sculptor, I had forgotten how little time there is." Three months later, he died. "I know that Wright the immovable atheist would chastise me for saying this," concluded Weiner, "but there are moments when, in a beautiful forest no map as ever shown, I envision Frank Lloyd Wright standing proudly before still a third Taliesin."[20]

In 1949, the bust of Wright was displayed at the Illinois Institute of Technology in Chicago.[21] A year after Wright's death, in 1960, it was included in the exhibition *Contemporary Portraits by Chicago Painters and Sculptors* at the Renaissance Society of the University of Chicago (fig. 64). Finally, in 1981, the piece was mounted on a boulder in Oak Park's Austin Gardens to celebrate the bicentennial of the end of the American Revolution. Wright's face looks up the street at all of the many houses he designed on Forest Avenue (figs. 65-67).

But the bust's adventures continued. In 1991, it was stolen from Austin Gardens—and returned when someone tried to cash it in at a metal recycler, who gave it back to the Park District. The statue was re-installed on the site, only to be vandalized with spray-paint in 2013 (it was cleaned and professionally restored.)[22] In spite of the bust's long and troubled history, it still graces Austin Gardens, just a few blocks away from Wright's home and studio.

[19] Egon Weiner and Paul G. Neimark, "The Face that Launched an Artistic Obsession," *Chicago Tribune Magazine*, April 27, 1969.

[20] Ibid. Another recollection of the encounter between Wright and Weiner was published in *Frank Lloyd Wright Remembered*, Patrick J. Meehan, ed., (Washington DC: The Preservation Press, 1991), 188-189.

[21] Carol Glennie, "Students View Modern Art as sculptor Exhibits at Tech."

[22] From recollection on the two incidents by Mike Grandy, superintendent of buildings and grounds, Oak Park Park District, Illinois.

RELIGIOUS ART: GOD THE CREATOR AND THE CREATIVITY OF THE ARTIST

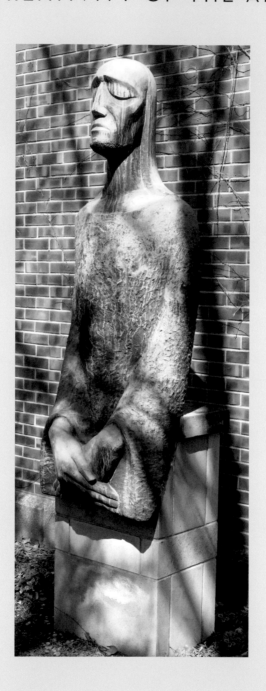

Figs. 70-71. Egon Weiner's bronze
Ecce Homo in the courtyard of
Augustana Lutheran Church, 5500
South Woodlawn Avenue in Chicago,
late 1960s. Photo by Anthony R. Stetina.

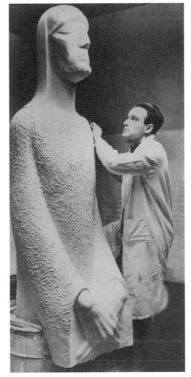

Weiner's philosophy on the nature of art and the source of creativity is rooted in his conception that "all art has an indication of religion." According to the artist, God created man in his own image—which means that humans have the same characteristics as God, including the ability to be creative. Weiner felt that the most important cultural event in America at that time was the "awakening of the importance of art and art education," and therefore, the artist should create "honest, meaningful expressions of religious truths." He admitted that the artist cannot compete with God, so he had to imitate him: "The artist wants to create something out of him alone, but nothing can be done alone. It is

Fig. 68. Egon Weiner working on *Ecce Homo,* 1939.

the spirit of God within the artist that produces the creative urge."[23] While his father was Jewish and his mother Catholic, Weiner chose Lutheranism,[24] an association that shaped his concept of religious art.

Weiner first created religious art at age 14 when he told his father about his desire to become an artist. His father didn't feel that this was a good career choice, noting that past artists had "starved." In response, young Weiner carved a head of Christ from plaster with a

Fig. 71. *See opposite page.*

knife, and convinced his father that he should be permitted to pursue his passion.[25] The large sculpture of mother and child pictured in the center of his Vienna Studio (fig. 24) was the start of a long career in producing religious art. Once he arrived in Chicago, Weiner created vast numbers of small-scale sculptures and monumental commissions depicting figures from the Old and New Testaments.

Ecce Homo (1939) is one of the earliest religious sculptures that Weiner produced in his Chicago studio (fig. 68). The statue, originally created in plaster, stood for 10 years in the Rockefeller Chapel balcony at the University of Chicago (fig. 69). In the late 1960s, the plaster was shipped to Norway, where it was cast in bronze. Upon its return to Chicago, *Ecce Homo* was placed in the

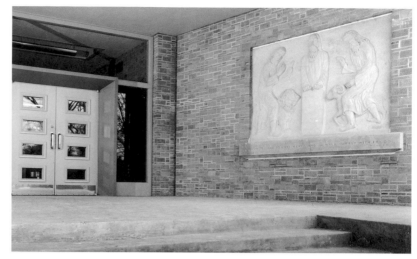

Fig. 74. Egon Weiner, Alfred S. Alschuler Memorial Sculpture at the North Shore Congregation Israel in Glencoe, Illinois (today Am Shalom), 1953. Photo by Hedrich-Blessing.

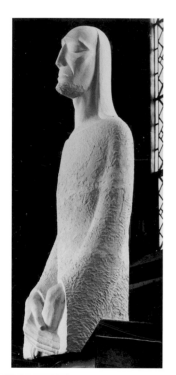

Fig 69. Egon Weiner's plaster of *Ecce Homo* in the balcony of the Rockefeller Chapel at the University of Chicago, 1950.

courtyard of Augustana Lutheran Church at 5500 South Woodlawn Avenue (figs. 70-71). This is Weiner's typical iconographic presentation of Christ and other religious figures: as an ordinary man without any traditional attributes, his face expressing human emotion, the gesture of his hands reflecting his state of mind. *Ecce Homo* represents Christ bound and crowned with thorns, just before his crucifixion—and refers to Pilate's phrase, "Behold the Man." Weiner subtracted the specific scriptural details, and Christ stands calmly with folded hands. The head, modeled in a moderate cubistic design, looks down with sorrow, accepting his fate.

Another religious theme Weiner explored early on is expressed in the 1939 *Prodigal Son* bronze (fig. 72). This parable, in the Gospel of Saint Luke, concerns a sinful son returning to his father—who accepts and forgives him. Weiner chose the traditional presentation for this theme: the son kneels in front of his father, who embraces him with affection. Like many of the artist's figures, the father is looking down humbly, physically and spiritually merged with his son.

Throughout his career Weiner also depicted several Old Testament figures. An early statue of Moses, created about the same time as *Prodigal Son*, is a very somber figure sitting and looking down in a state of meditation (fig. 73).

In 1953, Weiner installed a one-ton relief of Abraham, Moses, and David carved from Indiana stone at the North Shore Congregation Israel in Glencoe (today Am Shalom, figs. 74-75). Abraham holds a ram, Moses grips the tablet, and David stands next to a lion and plays the harp. The theme, which also was inscribed in the bottom of the relief, was taken from the prophet Micah: "It hath been told thee,

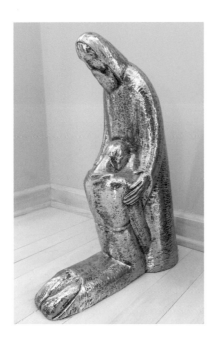

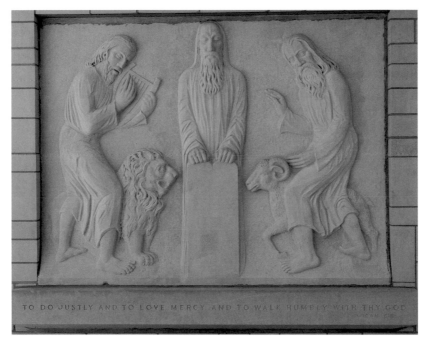

Fig. 72. Egon Weiner, *Prodigal Son*, 1939. Bronze, 19 x 6 x 13 in.

Fig. 73. Egon Weiner, *Moses*, c. early 1940s. Bronze, 22 x 8 x 12 in.

Fig 75. Egon Weiner, Alfred S. Alschuler Memorial Sculpture of Abraham, Moses, and David, 1953. Photos by Anthony R. Stetina.

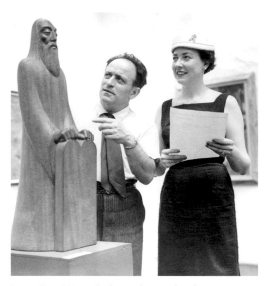

Fig 76. Egon Weiner looking at his wood sculpture *Moses* with Martha Larson, painting and drawing teacher at the School of the Art Institute of Chicago, June 1957. Courtesy of the *Chicago Sun-Times*.

O man, what is good, and what the Lord doth require of thee: only to do justly, and to love mercy, and to walk humbly with the God."[26] Weiner is guided by Micah's phrase, explaining that "the three ideas which struck me most forcibly in the text were justice, mercy, and humbleness."[27] He found humbleness in Abraham, who so loved his God that he was ready to sacrifice his son for Him. The center figure, Moses with the tablet, symbolizes justice—the law: "His face still reflecting the glory of his nearness to God and with his 10 fingers resting on the tablet (a finger for every law); in all, a man of utter dignity." Finally, he found mercy in David, who saved the life of his sleeping enemy King Saul. Weiner had highly personal feelings toward Psalms, and in particular to the idea of music that "must have been a source of comfort to him [David] and to others." According to the artist, "Psalms and music bring comfort to afflicted souls. To bring comfort is to be merciful."

In the late 1950s, Weiner carved another *Moses* out of mahogany, again with the tablet of the Ten Commandments (fig. 76). This *Moses* resembles the Glencoe relief: he is supported by the tablet, revealing his 10 fingers, and is looking forward with optimism. But many of the details in the previous *Moses*, such as the folds of the garment or the hair of his beard, were eliminated in the later version, as Weiner started to move toward abstraction.

Weiner had a special interest in the image of Saint Paul the Apostle, the dominant leader in the early Christian era who established significant

Fig. 77. Egon Weiner looking at his terracotta head of Saint Paul at the 12th Ceramic National traveling exhibition organized by the Syracuse Museum of Fine Art in April 1948 at the Marshall Field building on State Street, Chicago. Courtesy of the *Chicago Sun-Times*.

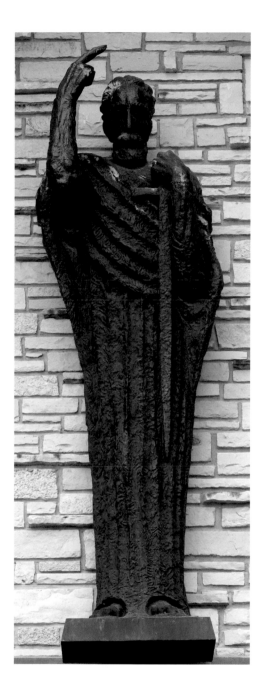

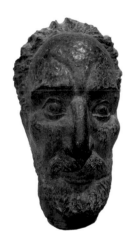

From left:
Fig. 80. Egon Weiner, *Preaching Saint Paul.* Photo by Anthony R. Stetina.

Fig. 78. Egon Weiner, *Head of Saint Paul,* c. early 1950s. Bronze, 15 x 9 x 12 in.

Fig. 79. Egon Weiner, *Preaching Saint Paul.* Bronze, 12 ft. high. Saint Paul Lutheran Church in Mount Prospect, Illinois, 1961.
Photo by Anthony R. Stetina.

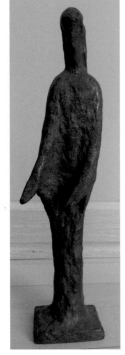

Fig. 82. Egon Weiner, model for *Learn of Me*, c. early 1960s. Bronze, 11 x 3 x 2 in.

theological principles. In accordance with his general habit of sculpting portraits based on his personal preferences, he modeled the bust of Saint Paul in terracotta (fig. 77) and bronze (fig. 78)—and he was looking for the opportunity to create a monumental statue of the Apostle.

In 1960, the congregation of Saint Paul Lutheran Church in Mount Prospect commissioned Weiner to sculpt and cast a 12-foot bronze statue of Saint Paul to be placed above the entrance of its new church. At that time, Weiner was working on his most significant outdoor sculpture, *Pillar of Fire,* and he cast both pieces in the Kristiania Kunst and Metalstoberi foundry in Oslo, Norway, using the lost wax method. In a letter to the Church's Pastor Zeile, Weiner explained the design: "I lifted only the right arm as if he [Saint Paul] would say, 'Grace be unto you,' and with his left hand he is holding the sword, which is his symbol." Saint Paul related to the Word of God as the "Sword of the Spirit." Although the statue was to be placed 15 feet above the ground and no one would be able to see its feet, Weiner decided "to model them as if they would be seen by everyone. After all, God would see them from above." During the casting process, Weiner fell three times from the scaffolding, but was never seriously hurt. Once completed, the statue was shipped to New York and trucked to Illinois. There was a bad snow storm along the way and the truck was lost for several days. But the sculpture, *Preaching Saint Paul,* was formally dedicated on April 23, 1961 (figs. 79-80).[28]

For his next commission, the artist returned to the presentation of Christ. In 1963, Weiner started *Learn of Me,* a monumental statue of Christ the Teacher for North Park College's Chicago campus. The idea of a figure that would symbolize the Christian values of North Park was first proposed by C. A. Nordberg of Evanston, who succeeded in interesting a donor, Harrison J. Bligh, in the project—and Weiner was commissioned to produce the statue. The 1,200-pound piece, cast in bronze at the same Oslo foundry, arrived at New York City in April 1964, where it was temporarily displayed at the World's Fair in 1964 and 1965. Eventually reaching Illinois, the sculpture was

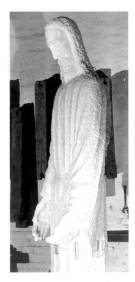

Fig. 83. Egon Weiner, plaster of *Learn of Me* before casting at the foundry in Oslo, Norway, 1963.

formally dedicated on June 10, 1967—where it was lauded "for the stimulus that comes to mind and personality of man through the fascination of light and shadow, color, lines, and forms; through the inspiration of design and symbol," and "for the creative skill of the sculptor and his ability to capture in bronze the spirit of the Master Teacher."[29]

Weiner recalled that when he was working on *Learn of Me* in Oslo, "words from Christ's parables and from John: 14, 'let not your heart be troubled,' filled my mind. I was so moved by all this that all my powers of expression were involved and the figure grew to a height of 10 feet almost before I was aware of it." And "on seeing it for the first time [at the New York Fair] since I left Oslo," he added, "I could not help that tears of joy and thanks came to my eyes (figs. 82-87)."[30]

In 1963, the same year that Weiner started work on *Learn of Me*, he also installed a monumental bronze relief of Christ over the entrance of the First Presbyterian Church in La Grange. The 14-by-14-foot, two-ton relief is based on the 100th Psalm, which is inscribed on the base: "Enter this court with Thanksgiving." The relief "depicts a standing figure of Christ with his arms out by his side. The sculpture presents an invitation expressed by the Psalmist for entry of everyone into the presence of God and depicts the reiteration of that universal and constant invitation by his posture and open hands. He stands beneath a design of interlocking arches."[31] The slim, flat, elongated body of Christ, and the pointed arches, were inspired by medieval Gothic art (figs. 88-91).

In 1967, Weiner completed his last monumental religious statue, mounting *Christ the King* on the exterior wall of Oslo's American Lutheran Church. During this time, Weiner took a year's leave from the School of the Art Institute of Chicago (SAIC), and from Augustana College (he was teaching at both) to concentrate on writing his book, *Art and Human Emotions,* and to work on the Oslo

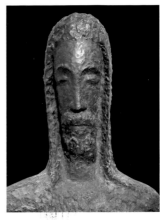

Fig. 87. Egon Weiner, head of *Learn of Me,* c. 1960s. Bronze, 25 x 21 x 6 in.

Fig. 88. Egon Weiner, plaster of *Enter this Court with Thanksgiving* before casting at the foundry in Oslo, Norway, c. early 1960s.

Fig. 92. Egon Weiner, plaster of *Christ the King* before casting at the foundry in Oslo, Norway, c. mid 1960s.

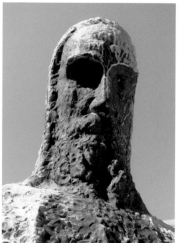

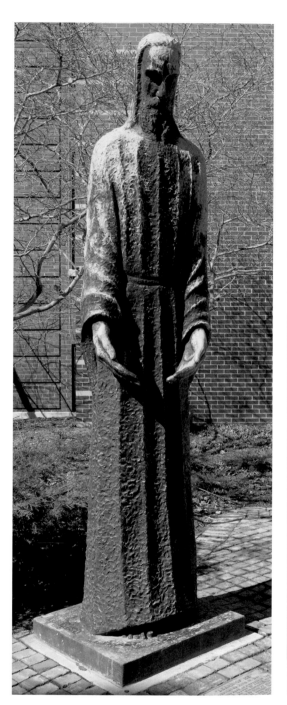

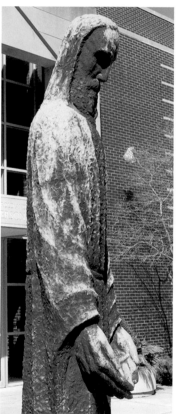

Fig. 84-86. Egon Weiner, *Learn of Me*, 1967. Bronze, 10 ft. high, North Park College campus in Chicago. Photos by Anthony R. Stetina.

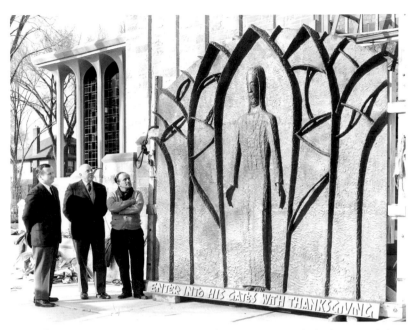

Fig. 89. Egon Winer supervising the installation of *Enter this Court with Thanksgiving* with the First Presbyterian Church's architect and a representative of the congregation, November 1963. Courtesy of the *Chicago Sun-Times*.

Fig. 93. Egon Weiner, head of *Christ the King*, c. late 1960s. Bronze, 31 x 42 x 16 in.

commission. *Christ the King* in Oslo and the Mt. Prospect statue of Saint Paul, both mounted on the façade of a church, share similar elements: each depicts an ordinary man shaped with simplicity, and each is notable for its absence of details—expressing the figure's message only through his hands. Weiner again distances himself from the traditional presentation of Christ, this time as a king, and instead of depicting him crowned and sitting on the throne, presents him standing, looking down modestly—a down-to-earth figure. He related the placement of the statue—mounted on the exterior of the church—to "the figurehead on the prow of a ship" (figs. 92-93).[32]

According to a pastor at the American Lutheran Church, the sculpture depicts Christ suspended with his right hand and arm raised in the form of blessing described in Luke's Gospel: "While he was blessing them, he withdrew from them and was carried up into heaven."[33] "The fingers of the right hand," explains the pastor, "are . . . slightly larger in proportion and held in the western tradition with the thumb and smaller fingers facing out together symbolizing the trinity and the two longer fingers pointing up signifying the two natures of Christ, fully human and fully divine" (figs. 94-95).[34]

Christ the King was dedicated on August 27, 1967, in the presence of the Norwegian King Olav V, and the American and Austrian ambassadors to Norway. Following the dedication, Weiner traveled to Austria to visit his son, Peter, who was studying filmmaking on a Fulbright

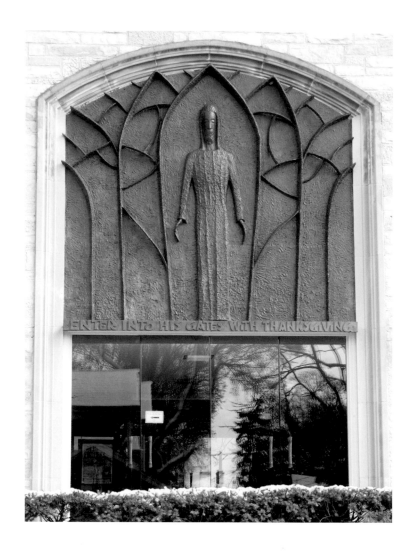

Figs. 90-91. Egon Weiner, *Enter this Court with Thanksgiving*, 1963. Bronze, 14 ft. high, First Presbyterian Church in La Grange, Illinois.
Photos by Anthony R. Stetina.

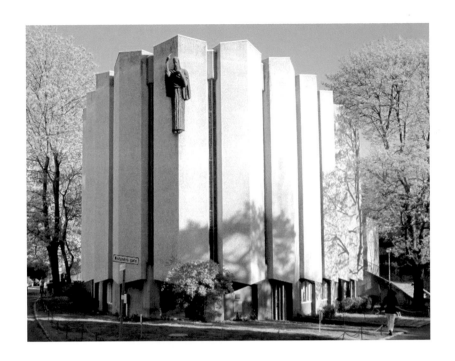

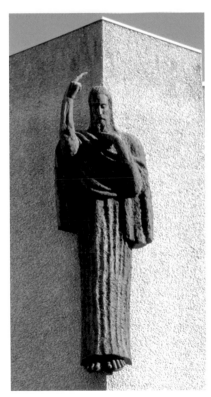

Figs. 94-95. Egon Weiner, *Christ the King*, 1967. Bronze, the American Lutheran church in Oslo, Norway.

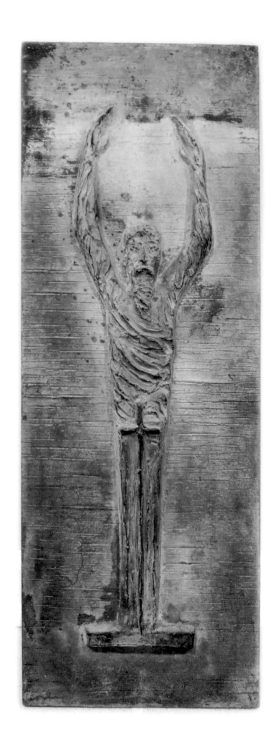

Fig. 98. Egon Weiner, *Christ*,
c. early 1960s. Bronze relief,
23 x 8 x 1 in.

Scholarship. He then visited museums in Milan, Paris, and London, and ended the trip with a visit to British sculptor Henry Moore (1898-1986).[35]

In addition to religious large-scale commissioned sculptures, Weiner also produced small-scale religious pieces, some of them as potential future enlargements. The bronze *Pieta* was acquired by the Immanuel Lutheran Church at 1500 West Elmdale Avenue in 1961 (fig. 96). The small piece echoes the composition and the semi-abstract design of Weiner's *Prodigal Son* (fig. 72). In both sculptures, the two figures—mother and the son in *Pieta* and father and the son in *Prodigal Son*—are physically unified to emphasize their deep spiritual link. The annual travels of the young artist to Italy still inspired some of his later sculptures. His *Pieta* echoes Michelangelo's late "unfinished" *Pieta* (as opposed to the master's earlier *Pieta*) in that the traditional presentation of the vertical mourning mother Mary and the horizontal dead body of her son Christ shaping the form of the cross is replaced with two unified vertical figures. Weiner added to his version of *Pieta* another personal preference: Christ is kneeling, and his hands are pushed behind. The distressed body of Christ and the dark patina of the bronze intensify the sadness of the event.

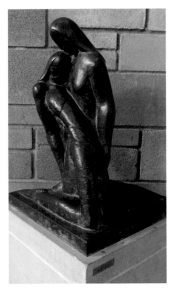

Fig. 96. Egon Weiner, *Pieta*, 1961. Bronze, Immanuel Lutheran Church, 1500 West Elmdale Avenue, Chicago. Photo by Anthony R. Stetina.

In his later work, the mahogany relief *Holy Family* (fig. 97), Weiner again merges the figures to illustrate spiritual unification. This effect is even more dramatic, as the artist's work is more abstract and maintains a dark surface.

Another example of a small-scale religious piece is the green-patina bronze relief of Christ lifting his hands up and standing in front of a cross-sword attribute (fig. 98). A unique, small free-standing figure looking up and holding a large sword was titled by the artist *The Fruit of Hate*—Weiner's only work that directly addresses the consequences of intolerance and human devastation in light of his own post-war experience (fig. 99).

As Weiner moved toward more extreme geometric abstraction in some of his works during the 1960s, several religious pieces were also drastically transformed. The 40-inch welded steel *Jacob's Ladder*, acquired by Chicago's Bethel Church in 1964, is an extreme example of the artist's new trend. The biblical episode of the angels ascending a ladder in Jacob's dream was visually altered to a curved line climbed by small butterfly-like elements. Weiner transformed the metaphor of this scene—the communication between humans and the Divine—to an almost surrealistic experience charged with musical rhythm (fig. 101).

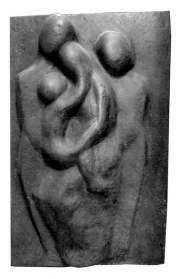

Fig. 97. Egon Weiner, *Holy Family*, c. late 1960s. Mahogany relief, 41 x 25.5 x 7.5 in.

In 1966, Weiner participated in the exhibition *Ecumenical Art* at Chicago's Saint Benet Gallery together with artists Gerald Hardy, Brone Jameikis, Misch Kohn, and Sister M. Rembert. He displayed several abstract sculptures, among them a steel *Mother and Child*, a

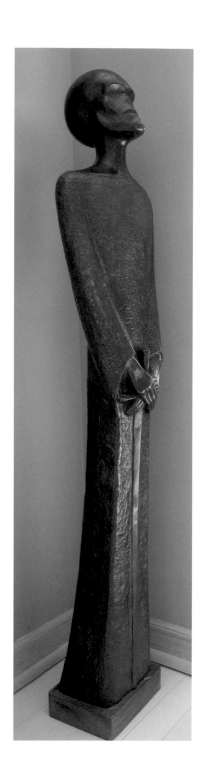

Fig. 99. Egon Weiner, *Fruit of Hate*,
c. 1950s. Bronze, 45 x 10 x 6 in.

repeated theme in the artist's career, but this time without any repre-
sentative element: an obscured amorphous image of mother standing
on one leg is lifting to the air a totally abstracted image of a child in an
almost acrobatic manner (fig. 102). "Art is more than a profession," wrote
Weiner in the exhibition catalog, "it is a sacred vocation. It is a search
for the secrets of the soul, a quest for the mystery of life. In my sculp-
ture, I endeavor to convey man's universal aspiration for the eternal."[36]

When Weiner designed a crucifixion piece for the King's Corner,
the storefront ministry of Christ the King Church in Chicago's Loop, he
delivered a plain four-foot, three-dimensional cross resting on a three-
step base with rough edges on one side and smooth edges on the
other—without the figure of Christ (fig. 103). "The rough surface is like
the heads of notes in music—you play them, they sound," explained
Weiner, adding "You notice the body of Christ is not on the cross. It
need not be on it; it is in it. Jesus was crucified once, that was enough.
The three-dimensional roughness suggests the body. People can
follow through to Christ. The three steps of the base are love, faith,
and hope."[37] The idea of a crucifixion without the body of Christ is
similar to the absence of the scythe at the hand of the *Reaper*. It is
again rooted in the psychological perception of the viewer as a funda-
mental principle of abstract art. "We're not reading our modern ideas
into modern art as we should," argues Weiner, "after all, Christianity is
substantially abstract . . ."[38]

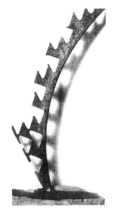

Fig. 101. Egon Weiner, *Jacob's Ladder*,
1964. Welded steel, 40 in. high.

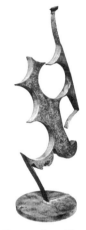

Fig. 102. Egon Weiner,
Mother and Child, 1966. Steel.

Fig. 103. Egon Weiner, *Cross*,
c. late 1960s. Bronze, 48 in. high.

23 Sally J. Parsons, "A Preacher in Sculpture," *The Lutheran* (April 12, 1967), 18-21.
24 From an interview with the artist's son, Andrew Weiner, June, 2014.
25 Carol Justice, "All Art Has Religious Meaning Says Prof. Weiner, Sculptor," *Panama City News Herald*
 (October 17, 1965).
26 Micah, 6:8.
27 From the North Shore Congregation's brochure for the dedication the Alfred S. Alschuler Memorial
 Sculpture by Egon Weiner, May 10, 1953.
28 *100th Anniversary News*, Saint Paul Lutheran Church, Mount Prospect, Illinois, December 2011.
29 From the program booklet for the dedication of the sculpture *Learn of Me*, North Park College,
 Chicago, June 10, 1967.
30 Press release from the Art Institute of Chicago, 1964, School of the Art Institute of Chicago archive.
31 Art Inventories Catalog, Inventory of American Sculpture, Smithsonian American Art Museum,
 Control Number: IL000297
32 "Weiner Statue Unveiled," *The Evanston Review* (January 25, 1968), 76.
33 Luke, 24: 51.
34 From the American Lutheran Church's 50 year anniversary blog, 2009.
35 "Weiner Statue Unveiled," *The Evanston Review*.
36 From the catalog for the exhibition *Ecumenical Art* (Forward by Martin E. Marty, University of Chicago),
 Saint Benet Gallery, Chicago, March, 1966.
37 Sally J. Parsons, "A Preacher in Sculpture."
38 Ibid.

TOWARD ABSTRACTION

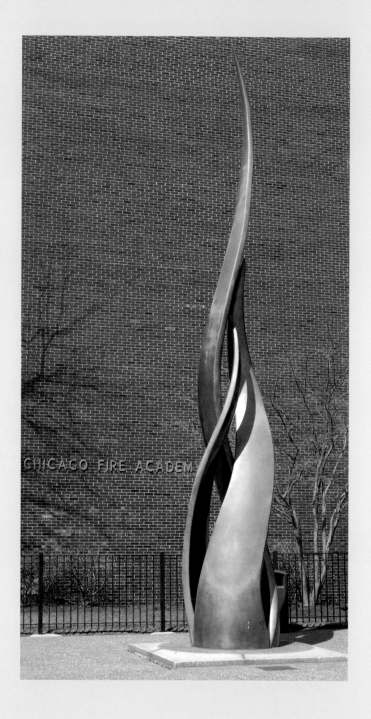

Fig. 109. Egon Weiner, *Pillar of Fire*,
outside the Fire Academy in Chicago,
1962. Bronze, 30 ft. high.
Photo by Anthony R. Stetina.

einer was attracted to abstract art early in his career, but until the late 1950s his use of abstraction was primarily limited to the elimination of details in figurative compositions. As was the case during his time in Vienna, when his experimental drawings signaled his artistic direction (figs. 11-12), a series of drawings from the late 1950s and early 1960s reveals Wiener's movement toward the abstract (figs. 104-107).

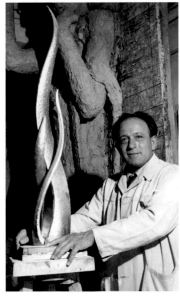

Fig. 112. Egon Weiner with a model of *Pillar of Fire* at the foundry in Oslo, Norway, 1962.

At the Art Institute of Chicago's 62nd annual *Artists of Chicago and Vicinity* exhibition in 1959, Weiner displayed not only a complete geometric abstract sculpture but also used a contemporary medium—forged iron using found objects—for the first time.[39]

Medicine Man (fig. 108), which won the Pauline Palmer Prize at that exhibition, depicts a totem-like pole crowned with a large mechanical wheel. The vertical element resembles a mace, a common ceremonial object carried by tribal healers, and the wheel symbolizes the mask of a shaman or a mandala, a tool for spiritual curing through meditation. The *Evanston Review,* writing about Weiner's Immigrants' Service League Distinguished Achievement Award (given to Chicago citizens of foreign birth), used a photo of *Medicine Man* to illustrate the article. Weiner, expecting readers' skepticism toward such a contemporary work, tried to defend the new trend in that article, noting, "The modern artist has to be courageous and adventurous. People who want to understand modern art have to be courageous and adventurous, too. We have to learn new ways of seeing and hearing not only in art but also in everyday life."[40]

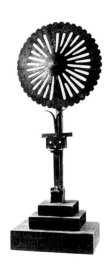

Fig. 108. Egon Weiner, *Medicine Man*, 1959. Forged iron.

In 1962, Weiner erected the 30-foot *Pillar of Fire,* his largest and most prominent abstracted monument (figs. 109-111), at 558 West DeKoven Street. He got the commission by winning a competition to design a sculpture commemorating the 1871 Chicago Fire for the Fire Academy. Weiner prepared all his preliminary sketches and compositions and studied every historical aspect of the fire. "As a human being with artistic feelings," explained Weiner, "I could feel what misery fire could cause. I could trace and retrace the emotions that a disaster of such greatness could bring without the data. I read later about the reality, and it confirmed the first instinct I had about it."[41]

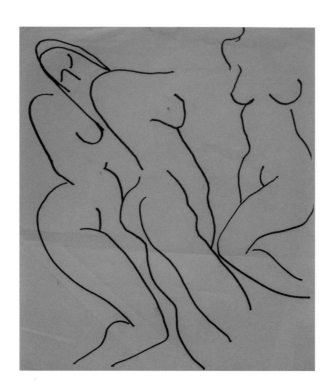

Fig. 104. Egon Weiner, *Three Nude Women,*
c. late 1950s. Markers on paper, 17 x 14 in.

Fig. 105. Egon Weiner, *Abstract Figure,*
c. late 1950s. Markers on paper board,
17.5 x 17.5 in.

Fig. 106. Egon Weiner, *Abstract Form*, c. late 1950s. Markers on a paper board, 17.5 x 17.5 in.

Fig. 107. Egon Weiner, *Abstract Form*, c. late 1950s. Ink on paper, 16.5 x 11.5 in.

The Academy, created to educate firefighters, was built on the spot where the Chicago Fire broke out. Because Mrs. O'Leary's cow supposedly started the fire, there were several competitors who wanted to depict the unfortunate animal. "Thank God," said Weiner, "that idea didn't win . . . fire isn't just a cow kicking over a lamp. Fire can be a curse, a blessing, and I was the only one that showed the fire in a more creative way."[42] In the first model for *Pillar of Fire,* Weiner started with movement—as fire always moves. With that, he won the preliminary competition and

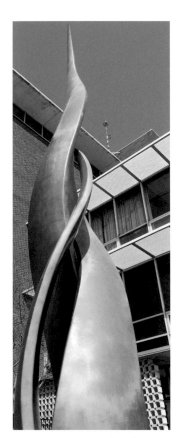

Fig. 111. Egon Weiner, *Pillar of Fire.* Photo by Anthony R. Stetina.

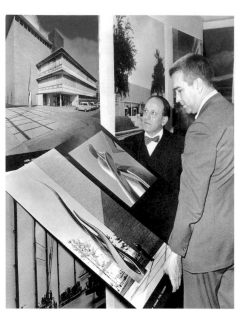

Fig 113. Egon Weiner presenting photos of *Pillar of Fire* to George Danforth, dean of architecture and planning at Illinois Institute of Technology during the American Institute of Architects Honor Award ceremony, April 1962. Courtesy of the *Chicago Sun-Times.*

became a finalist. Then, Weiner reduced the form to five flames and in the required writing statement described the main motifs of his proposal: the creativity of fire, the disaster, the sunrays, the warmth, the destruction, and even the symbol of the flame as the Holy Ghost. In the final version, the piece was reduced to only three flames. As the artist explained, "the three intertwined flames symbolize the Holy Trinity, as does the triangular source of light at the base."[43]

In Norway, after Weiner won the final competition, he developed two models from a sketch. First, he made a small-scale model, then a larger one, and eventually started to work directly in sections of plaster of Paris (fig. 112). Weiner and his assistant built the sculpture like a wing of an airplane, circling the inside circumferences "the way one would go up a spiral staircase." Then they covered the framework with plaster of Paris and developed "the elegant swing of composition."

"The *Pillar of Fire,*" recalled Weiner, "was a monumental work. I built it up like a tower." When it was cast in bronze, the work was completed in sections, that Weiner and his assistant put together using a scaffold. Ultimately, it took a year to make the plaster and another year to cast the piece in bronze. Once it was finished, the sculpture was packed in several pieces for shipment. When *Pillar of Fire* was unpacked in Chicago, the artist actually saw it for the first time as a whole entity. "I worked two years on *Pillar of Fire,*" writes

Weiner, "and when it was erected, I was still on fire with nothing to burn."[44] In 1962, Weiner won the American Institute of Architects Honor Award for *Pillar of Fire* (fig. 113). Ten years later, the sculpture was designated a Chicago landmark by the Commission on Chicago Historical and Architectural Landmarks.[45]

Following the dedication of *Pillar of Fire*, Weiner created a small-scale version of the sculpture for the Immanuel Lutheran Church in Chicago where the artist's *Pieta* (fig. 96) was also on display (fig. 114). The first Immanuel Lutheran Church burnt down in the Chicago Fire, and Weiner's small piece paid homage not only to that tragic event but to the resilience and survival of the congregation.

Weiner also produced several small sculptures that were stylistically and thematically related to *Pillar of Fire*. In two versions of the *Burning Bush,* he maintained the composition of flames bursting upward but with more complicated composition of multiple flames. One of them kept the polished bronze patina of *Pillar of Fire* (fig. 115); the other was made of steel and bolts (fig. 116). The metaphor of the *Burning Bush* is similar to the symbolism of *Pillar of Fire,* as for Moses, the bush that burned but was not consumed symbolized survival or revival.

In 1965, Weiner used the composition of *Pillar of Fire* for another commission: a stained glass window at the Hammarskjöld Meditation Room at Augustana College in Rock Island (figs. 117-118). The glass was made of pieces of rock-glass ground into shape with diamonds and put together with epoxy. At the center of the window is a flame. "Fire is a very vital part of our lives," Weiner wrote in the dedication brochure, "from the life-giving and warming surface of the sun to the destroying power of the fire eruptions of a volcano, the blessing and dangers of fire go through the history of mankind." According to the artist, "Fire is used as a symbol in many religions. In the Old Testament, the 'burning bush of Moses' is an example."[46]

In 1963, Weiner installed *Polyphony,* a 10-foot-high bronze sculpture, on the campus of the University of Wisconsin — Milwaukee (figs. 119-120). He had been an artist-in-residence there a year earlier when the Music Building was completed, and was invited to place a piece

Fig. 117. Egon Weiner, study for a stained glass window at the Augustana College Hammarskjöld Meditation Room, Rock Island, Illinois, 1965. Colored pencils on paper board, 9.5 x 6 in.

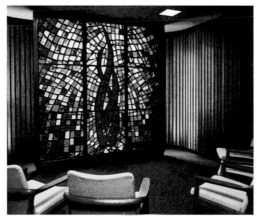

Fig. 118. Egon Weiner, stained glass window at the Hammarskjöld Meditation room.

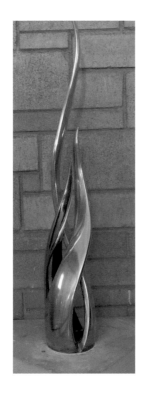

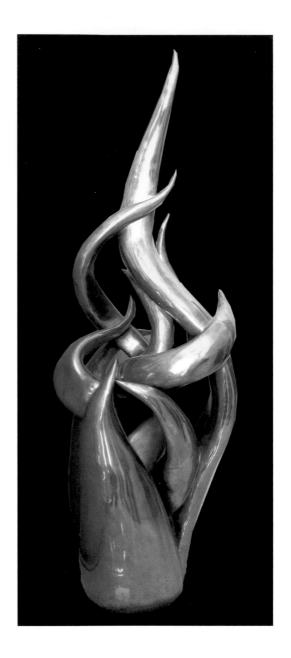

Fig. 114. Egon Weiner, small version
of *Pillar of Fire* at Immanuel Lutheran
Church in Chicago.
Photo by Anthony R. Stetina.

Fig. 115. Egon Weiner, *Burning Bush*,
c. 1962. Bronze, 74 x 22 x 13 in.

Fig. 116. Egon Weiner, *Burning Bush*,
c. 1960s. Steel and bolts, 76 x 20 x 15 in.

Fig. 121. Egon Weiner, *Polyphony II*, 1965. Bronze, Marina City, Chicago.

in front of the structure. Years later, when the building became part of the University's Arts Center, the sculpture was temporary stored and eventually re-installed next to the Student Union. In 1964, the artist created *Polyphony II*—a smaller version of the UWM bronze that maintained the same formal structure. It was dedicated in November 1, 1965, on the plaza of Chicago's Marina City, just above the ice skating rink (fig. 121). Later, *Polyphony II* was relocated to the southeast corner of Saint Joseph Hospital on Lake Shore Drive—not far from Weiner's *Brotherhood* (fig. 122).

Both versions of *Polyphony* echo Weiner's long-time interest in art and music. As the word "polyphony" refers to a variety of tones or voices in music, so the different arrow-like elements in Weiner's sculptures pull in different directions and create harmony out of chaos. Weiner perceived the composition of *Polyphony* as the expression of "the rhythm and motion of conductor's baton,"[47] or "the rhythm of music and its inner structure."[48]

During the late 1960s, Weiner produced small metal sculptures made of steel or aluminum as experimental pieces or as practice runs for possible large-scale outdoor sculptures (figs. 123-125). These pieces are more fluid, resembling the amorphous forms created by such artists as Jean Arp (1886-1966) or the geometric abstractions of sculptor David Smith (1906-1965). A unique bronze Weiner developed and cast in Norway at that time was *Troll*, inspired by local Scandinavian folklore (fig. 126). The sculpture features three kneeling figures emerging from a center core and looking in different directions. The kneeling echoes *Brotherhood*, but the expressionistic mode of *Troll* is inspired by the artist's religious works as opposed to his abstract sculptures such as *Pillar of Fire* or *Polyphony II*.

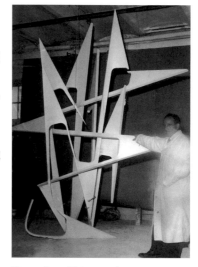

Fig. 119. Egon Weiner working on *Polyphony* for the University of Wisconsin – Milwaukee in the foundry in Oslo, Norway, c. early 1960s.

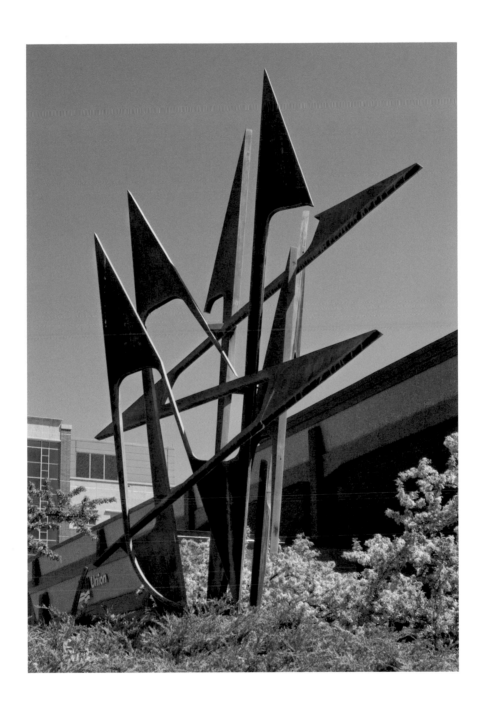

Fig. 120. Egon Weiner, *Polyphony*, 1963. Bronze, 10 ft. high, University of Wisconsin – Milwaukee campus. Photo by Alan Magayne-Roshak, UWM Photo Services.

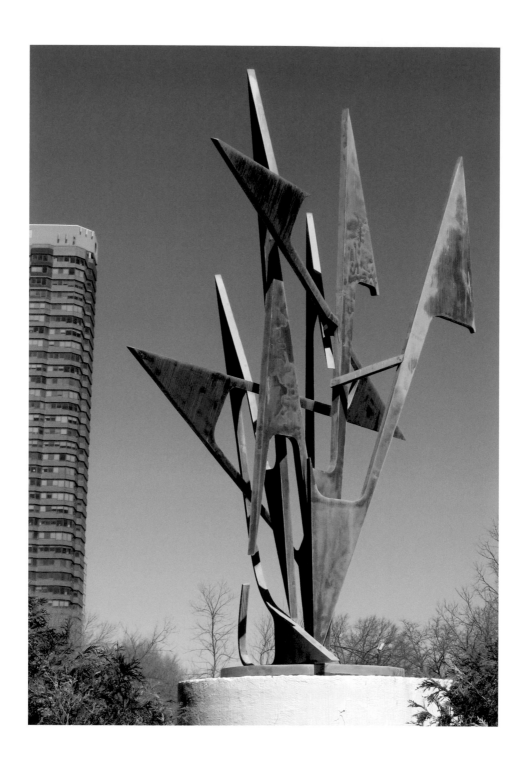

Fig. 122. Egon Weiner, *Polyphony II*, outside of Saint Joseph Hospital on Lake Shore Drive, Chicago. Photo by Anthony R. Stetina.

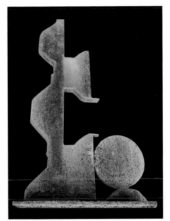

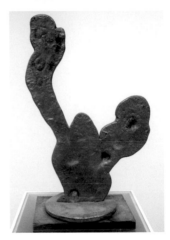

Clockwise from left:
Fig. 123. Egon Weiner, *Flying Form*,
c. late 1960s. Steel, 18.5 x 15.5 x 11.5· in.

Fig. 124. Egon Weiner, *Abstract Form*,
c. late 1960s. Steel, 25.5 x 15 x 9 in.

Fig. 125. Egon Weiner, *Abstract Form*,
c. late 1960s. Aluminum, 17 x 8 x 6 in.

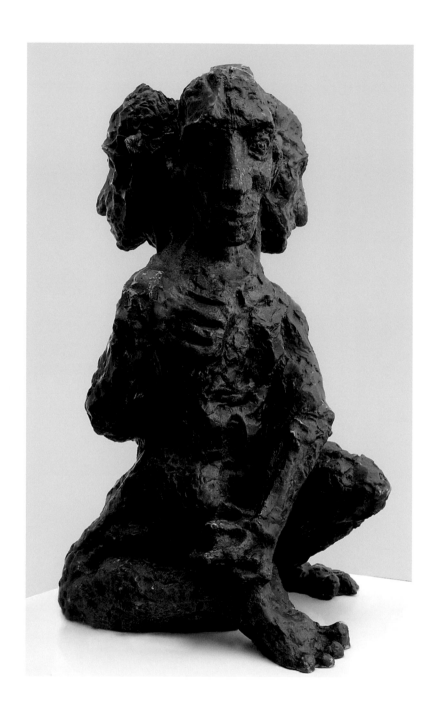

Fig. 126. Egon Weiner, *Troll*, c. 1960s.
Bronze, 24 in. high. Collection of the
Koehnline Museum of Art. 2010.20.
Gift in memory of Nancy Bild Wolf
(1929-2010) from her husband and
four children. Wolf enjoyed this
statue in her Glencoe, Illinois garden
for more than 20 years.

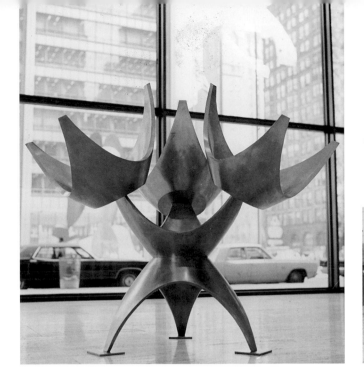

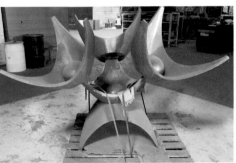

One of Wiener's last large sculptures was the four-foot-high bronze *Moon Flower*, displayed temporarily in the lobby of the building on Washington Street just south of Daley Plaza in downtown Chicago to celebrate the first anniversary of the moon landing on July 16, 1969 (figs. 127-129). Previously, a small model of *Moon Flower* had been dedicated to the Apollo 11 astronauts on June 20, 1969, prior to their heroic expedition. The label next to the sculpture declared: "The artist's concern is to bring to conquest of space a peaceful symbol representing the flowering of man's intellect, which enabled him to break bonds of earth, a symbol of life and creativity."[49] Weiner skillfully composed a form that is simultaneously organic and scientific: *Moon Flower* resembles the Eagle lunar module that carried the astronauts to the surface of the moon, and the large flower petals open like radar dishes. Possibly, Weiner also had his mother in mind when he designed *Moon Flower*: in his book *Art and Human Emotions* he recalled how much she loved flowers, noting that whenever he saw a flower he met her again.

Clockwise from left:
Fig. 128. Egon Weiner, *Moon Flower* on display in the lobby of the building across from Daley Plaza in Chicago, 1970.

Fig. 127. Egon Weiner, Study for *Moon Flower*, c. late 1960s. Pencil drawing, 12 x 12 in.

Fig. 129. *Moon Flower* at the Bucthel Metal Finishing factory in Elk Grove Village, Illinois.
Photo by Anthony R. Stetina.

[39] From the Art Institute of Chicago's catalog *Annual Exhibitions by Artists of Chicago and Vicinity*, May 13 – June 28, 1959, catalog no. 175.
[40] Ann Feuer, "Sculptor Egon Weiner Given Award," *Evanston Review* (November 24, 1966).
[41] Egon Weiner, *Art and Human Emotions* (Springfield, IL: Charles C. Thomas, 1975), 73.
[42] Ibid.
[43] Ira J. Bach, Mary Lackritz Gray, and Mary Alice Molloy, *A Guide to Chicago's Public Sculpture*, 223.
[44] Egon Weiner, *Art and Human Emotions*, 77.
[45] Letter to Egon Weiner from William M. McLenahan, director of the Commission on Chicago Historical and Architectural Landmarks, January 28, 1972, School of the Art Institute of Chicago archive.
[46] From the brochure of the Hammarskjöld Meditation Room in Augustana College in Rock Island, Illinois, February 15, 1965.
[47] Steven Dahlman, *City Within City. The Biography of Chicago's Marina City* (online book), October, 2012.
[48] Diane Buck (author) and Virginia A. Palmer (contributor), *Outdoor Sculpture In Milwaukee: A Cultural And Historical Guidebook* (Wisconsin Historical Society Press, December 15, 1995), 131.
[49] From a text label positioned next to *Moon Flower* in summer 1970 in the lobby of the building on Washington street south of Daley Plaza.

THE EDUCATOR: ART AND HUMAN EMOTIONS

Egon Weiner sculpting a snowman on
Michigan Avenue outside the Art
Institute of Chicago in 1959.
Courtesy of the *Chicago Sun-Times*.

Weiner believed that being an artist and being an educator were inseparably linked, and throughout his lengthy career he was deeply involved in teaching, presenting, and writing about different aspects of art and creativity. With a brief experience in art teaching in Vienna, he began offering private classes as soon as he established his Chicago studio in 1938—but it took him several years until he started teaching in an art school.

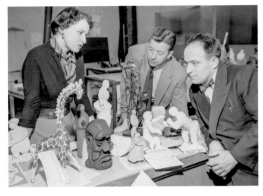

In his first application to teach at the School of the Art Institute of Chicago (SAIC), dated July 14, 1942, Weiner detailed his education and teaching experience in Vienna and Chicago, and rated his preferred subjects: "1. Understanding the form and expression of modern sculpture, 2. Woodcarving, 3. Stone-carving, 4. Work in terracotta, 5. Sketching and modeling after life model, 6. Anatomy."[50]

Fig. 130. Egon Weiner and sculptor Patricia Watters jurying students' works, c. 1950s. Courtesy of the *Chicago Sun-Times*.

In June 1945, Weiner wrote a letter to artist Hubert Ropp (1894-1973), then the dean of the SAIC, asking for a review of his education, teaching experience, and record of exhibitions, and noting, "I would very much appreciate an opportunity to teach at your school."[51] In this letter, he also included a list of references: Urlich Middeldorf (1901-1983) from the University of Chicago's Art History Department, who was also at that time an honorary curator of sculpture at the Art Institute of Chicago; artist and teacher Dudley [Crafts] Watson (1885-1972); and artist and associate lecturer George Buehr (1905-1983) (both from the Art Institute of Chicago.)

Finally, Weiner's application was accepted, and from 1945 to 1971 he was a professor of sculpture and life drawing at the SAIC (fig. 130). During that time, he was teacher and mentor to several students who later became Chicago sculptors, including Joseph Burlini, Cosmo Campoli, Richard Hunt, Konstantin Milonadis, and the artist's son Andrew Weiner.

Burlini (fig. 131) studied industrial design at the SAIC between 1956 and 1960. He recalls that his classes were conducted in the Art Institute basement near the railroad tracks, remembering Weiner as "an amazing man. I have never before met someone with so much energy—he was excited about everything he did." Burlini also recalls an amusing incident: a student in his sculpture class liked to whistle. Nobody could stand it, but all remained silent until Weiner, who taught a class next door, stormed into the classroom one day shouting, "Stop that whistling, stop that whistling!" in his German accent. "[Weiner] always had his little beret on," remembers Burlini, "and he was always running up and down the hallways." Burlini notes that the SAIC had a very unusual approach to building its faculty: teachers were also full-time

Fig. 131. Artist Joseph Burlini in his
home and studio, Arlington Heights,
Illinois. May 2014.

Fig. 132. Artist Richard Hunt in his
Lill Street studio, Chicago, June 2014.

Photos by Jesse Wallace.

artists, and Weiner was one of them. When Burlini was teaching sculpture at the Illinois Institute of Technology, he adapted Weiner's philosophy of teaching by passing his own passion and energy to his students.[52]

Renowned Chicago artist Richard Hunt (fig. 132) entered the SAIC in 1953. After taking foundation courses he decided to become a sculptor, and enrolled in Weiner's class. Hunt remembers Weiner as "a short man, full of energy, open for discussions, and always talking passionately about art." He appreciated his teachers, including Weiner, who emigrated from Europe as refugees and shared not only their vast knowledge of art, but also a range of cultural views. Sculpture classes at that time, according to Hunt, focused on modeling of figures, and when the students acquired their skills in working in clay and plaster they moved to carving. Hunt was less interested in carving sculptures than he was in working with metal, and luckily Weiner fostered and supported this interest. Hunt also remembers how Weiner loved music, and he encouraged his students to listen to music when they were working in class. When the artist came to class the day after listening to his favorite Hungarian conductor Fritz Reiner at Symphony Center, "he would send his students to listen to music rather than sculpting." According to Hunt, Weiner's sculptures *Brotherhood* and *Pillar of Fire* were inspired by *Ode to Joy* in Beethoven's Symphony No. 9. Now, when he surveys his own sculptures—many of which have exploding tops—Hunt cannot help but think of his teacher Weiner and his more abstract works such as *Pillar of Fire*. Hunt remembers Weiner for "his exuberance and nurturing manner—and for being a bundle of energy."[53]

Both Weiner's sons, Peter and Andrew, followed their father's path into the world of art. "I never said anything about art to them" said Weiner in a newspaper's interview, "but they were surrounded by it and this was stronger than words."[54] Peter studied with Chicago artist and teacher Misch Kohn (1916-2003) at the Illinois Institute of Technology's Institute of Design in the late 1960s, and later studied filmmaking in Austria on a Fulbright Scholarship. Andrew (fig. 133) enrolled in Temple University's Tyler School of Fine Arts after studying at the SAIC. When Andrew took Weiner's sculpture classes, some of the students asked whether he got special help from his father, but the artist had told him from the start: "If you are going to be a sculptor, you have to do it yourself. I'm not going to give you any special help." Andrew reports (as does Hunt) that his father did not try to impose his own method or style on his students, allowing them to develop their own direction following their gut feelings.[55] In addition to his full-time teaching position at the SAIC, Weiner was a visiting professor at Augustana College from 1957 to 1971, when he retired from both schools.[56]

Fig. 133. Artist Andrew Weiner at the Koehnline Museum of Art, June 2014. Photo by Jesse Wallace.

Inspired by his psychiatrist wife and his early experiences in Vienna, a major center for modern psychology at that time, Weiner began exploring the correlation between art and psychology in 1965. That year, he participated in a psychological study, conducted by the Treatment and Research Center in Chicago,[57] involving children and their parents that included a series of drawings depicting their relationship.

In 1966, Weiner presented at the Arts and Humanities Session of the American Psychiatric Association Annual Meeting in Atlantic City. Using themes that would later find their way into his book, he spoke on "Modern Art and Human Emotions," focusing on the beginnings of art, its relationship to human development, artistic movement throughout the ages, and impressions and expressions. The presentation was illustrated by slides of the artist's current drawings and clay modeling pieces. "The viewers of modern art," writes Weiner in the session's program, "must be as courageous and adventurous as the modern artist, and perhaps even less hidebound."[58]

The *Washington Post,* which covered the meeting, wrote, "Weiner was speaking here [at the meeting] in the unlikely role of telling psychiatrists that art and art forms may be useful in diagnosing and treating mentally ill patients."[59] A thank-you letter from the American Psychiatric Association expressed its deep appreciation for his presentation, noting, "In our minds, we have appointed you a psychiatrist emeritus. Either you have a lot of native intuition or you have learned a lot from your wife."[60]

Following Weiner's presentation, Payne Thomas, of Charles C

Thomas Publisher Ltd., invited the artist to write a book expanding on the art and emotions theme.[61] Weiner accepted, and took a one-year leave of absence from the SAIC to work on the manuscript. In his leave request letter to Roger Gilmore, the School's dean, Weiner explains the need for such a book, describing his successful presentation in

Atlantic City and the publisher's offer. "My interest in the field of art and human emotions began many years ago," he writes, "but the opportunity to formulate and express my thinking on this subject have greatly increased in recent years."[62]

Art and Human Emotions (fig. 134) was published in 1975, and it "presents Weiner's collection of lectures given spontaneously to stimulate interest in and promote understanding of modern art and its emotional impact".[63] He used a "free-association" style—a term borrowed from Freud's psychoanalysis method. The book summarizes Weiner's philosophy about art and creativity based on many years of traveling and working as an artist, teacher, and lecturer.

Fig. 134. Cover of Egon Weiner's book *Art and Human Emotions*, published 1975.

In the first chapter, Weiner gives a rare glimpse into his classroom and teaching style, which was based on optimism and psychology:

I teach drawing and sculpture, and when I walk around and stop, the students are a little disturbed. It is like the piano teacher coming and looking over your shoulder—then you play a few sour notes. So I look, and he or she looks up and says, "Well, this is not a good drawing; it is horrible," before I say a word. And I look at it—I must say I cannot lie to a student. So I say, "It is bad; it is not so good." Then I say, "Who do you think made it?" Well, there's a sort of surprise in the face of the student, and he says, "I did." I say, "You know what? You should be very happy about it. You save yourself a nightmare. Be glad you got it out of your system."[64]

Throughout his book, Weiner records his artistic preferences with regard to styles and artists. He also describes his fascination with the Spanish artist El Greco (1541-1614), forgotten for 300 years until he was re-discovered by the German art historian Walter Meier Graefe, who wrote a book about him. "The discovery of El Greco," writes Weiner, "changed the history of painting. Modern artists . . . adopted El Greco as their leading artist, even if he did paint three hundred years before them (fig. 135)."[65]

At the beginning of the book, Weiner includes a poem he wrote to his mother with a footnote saying: "She died in Europe during the war. We do not know how, when, or where."

Fig. 135. Eighty-year-old Egon Weiner viewing a painting by El Greco at the Art Institute of Chicago.

Fig. 137. Elsa Weiner in Austria, c. 1920s.

Fig. 136. Elsa Weiner with her husband Moritz and three sons (Egon in the middle) in Vienna, c. 1910.

To my Mother

When in springtime
The flowers grow again
After a lonesome, dreary winter,
We are all happy,
And I am even happier
Because I know
My Mother loved flowers so much.
They grow and bloom
And when I look at them
Face to face - a whispering question –
"How are you, my son?"
And I answer with tears in my eyes
And an inexpressible feeling,
"I am fine, dear Mother."
Whenever I see flowers
I meet my Mother again.[66]

Weiner's mother Elsa continued to inspire him, although he never saw her again after leaving Vienna. Many of his mother and child sculptures and *Moon Flower* pay homage to his affection for her (fig. 136-137). Weiner referred often to his mother—for example, when he carved Johnny Appleseed out of an apple-tree trunk, he remembered how she had given him apple strudel and fresh apples when he fled to the United States.[67] Weiner's optimism and humor fueled his unstoppable creative force during his life and his career. Like his "flame" sculptures—including the *Burning Bush* and *Pillar of Fire*— his fiery energy continued to blossom like flowers.

Unfortunately, from the end of the 1960s until Weiner's passing in 1987, his tremendous energy declined as a result of ill health, including heart disease that worsened after a taxi struck him during one of his frequent visits to Norway.[68] But Weiner continued to receive affectionate support and recognition for his prolific career as an artist, teacher, and source of inspiration. In 1969, he received a Gold Medal Award from the Municipal Art League of Chicago, because "the masterpieces you [Weiner] have created are today enjoyed by millions, in museums, churches, public buildings, on campuses and in private collections, in many countries of the world." The award also references Weiner the educator: "Your teaching as professor of sculpture and figure drawing at the Art Institute and Augustana College have inspired and enriched thousands of students to 'carry on' in the highest tradition of art."[69]

In 1970, Weiner participated in the most outstanding artistic event of that year, organized by the Evanston chapter of the National Society of Arts and Letters at the home of the chapter's founder, Alma Dalmar. After delivering a lecture, he was presented with a gold medal "for his outstanding contribution to the arts both as an artist and a teacher."[70] Plaques of the award were sent to Norway, where Weiner had sculpture commissions, and to his native Austria where he started his career. Weiner also presented a small model of *Moon Flower* to the audience (fig. 138).

A year later, Weiner retired from teaching at the SAIC. A letter from Dean Roger Gilmore confirmed Weiner as a professor emeritus in recognition of his "dedicated and inspired teaching at the school, which spanned an impressive twenty-six years." Gilmore also mentioned Weiner's "contribution to society as an artist" which "has been extensive and significant."[71] Weiner visited Oslo again in 1972, and delivered a lecture about the Norwegian artist Edvard Munch (1863-1944). [72] In 1978, he was presented with one of the highest Austrian awards: the Austrian Cross of Honor for Science and Art First Class. The ceremony, sponsored by the SAIC and the Austrian Consul General in Chicago, took place at the Trading Room in the Art Institute of Chicago.[73]

Fig. 138. Egon Weiner showing a small version of *Moon Flower* during the ceremony of the Evanston, Illinois, chapter of the National Society of Arts and Letters, at which he received a gold medal for his achievements, 1970.

In the 1980s, Weiner's activities continued to decrease, although he made a few public appearances. He gave a lecture titled "What art Means to us Today" at the Mezzanine 12 Art Gallery in the Palmer House Hotel in October 1984[74], and attended his own 80th birthday celebration at the Blackstone Hotel organized by the Crystal Ballroom Concert Association on July 23, 1986. The celebration included a concert of contemporary American and European composers, and introductory remarks by the artist's friend, musician Francois D'Albert: "Egon Weiner, the Artist, the Creator of Masterpieces, the Man and Friend."[75]

A year later, on July 6, 1987, Gilmore sent his last letter to Weiner: "I was pleased to see Andrew [the artist's son] last week at school and I thought of you again when we were at the Cliff Dwellers [Club] for the Grant Park fireworks display Friday night July 3. I am sorry you are not very well physically, but I know your spirit is as strong and life-loving as ever."[76] Three weeks later, on July 28, Weiner passed away in Evanston Hospital. "Egon meant a lot to us and he will be sorely missed," wrote Dean Gilmore in a letter to the artist's family, "He lived life with a joy and commitment that were an inspiration to many."[77]

[50] "Application for Teaching Assignments (Fine Arts – Design)," July 14, 1942, School of the Art Institute of Chicago archive.

[51] Letter from Egon Weiner to Hubert Ropp, dean of the School of the Art Institute, June 3, 1945, School of the Art Institute of Chicago archive.

[52] Interview with Joseph Burlini at the artist's home and studio in Arlington Heights, Illinois, May 29, 2014.

[53] Interview with Richard Hunt at his Lill Street studio in Chicago, Illinois, June 5, 2014.

[54] Ann Feuer, "Sculptor Egon Weiner Given Award."

[55] Interview with Andrew Weiner at Oakton Community College's Koehnline Museum Art, Des Plaines, Illinois, June 3, 2014.

[56] Egon Weiner's collection at Augustana College consists of articles by or about Weiner and organized into five areas: Personal, Correspondence, Writing, Publicity, and Photographs. It covers the artist's career between 1947 and 1972.

[57] From a letter to Egon Weiner from Gunther Rice of the Treatment and Research Center, Chicago, March 9, 1965, School of the Art Institute of Chicago archive.

[58] From the program of The Arts and Humanities Session, American Psychiatric Association 122nd Annual Meeting, Atlantic City, May 11, 1966, School of the Art Institute of Chicago archive.

[59] Nate Haseltine, "Art May Help Insane, Doctors Told," *Washington Post*, May 12, 1966.

[60] From a letter from the American Psychiatric Association to Egon Weiner, May 16, 1966, School of the Art Institute of Chicago archive.

[61] A letter from Payne Thomas, Charles C Thomas Publisher Ltd., to Egon Weiner, June 21, 1966.

[62] A letter from Egon Weiner to Roger Gilmore, dean of the School of the Art Institute of Chicago, December 10, 1966, School of the Art Institute of Chicago archive.

[63] From the jacket flap of *Art and Human Emotions*.

[64] Egon Weiner, *Art and Human Emotions*, 6.

[65] Ibid., 50.

[66] Ibid., v.

[67] Kenan Heise, "Obituaries: Egon Weiner; Sculptor, Art Institute Instructor," *Chicago Tribune*, July 30, 1987.

[68] Interview with Stephanie Weiner, Des Plaines, Illinois, June 9, 2014.

[69] From the Municipal Art League of Chicago's award, January 29, 1969, School of the Art Institute of Chicago archive.

[70] Electa Tideman, "Evanston Chapter," *The Record* (The National Society of Arts and Letters, Spring issue, 1970), 6.

[71] Letter to Egon Weiner from Roger Gilmore, dean of the School of the Art Institute of Chicago, June 14, 1971, School of the Art Institute of Chicago archive.

[72] From a letter to Egon Weiner from Wilma LaMee, secretary to the director, Embassy of the United State of America, Oslo, Norway, November 27, 1972, School of the Art Institute of Chicago archive.

[73] Announcement from the School of the Art Institute of Chicago and the Austrian Consul General in Chicago for the presentation of the Austrian Cross of Honour for Science and Art First Class, February 24, 1978, School of the Art Institute of Chicago archive.

[74] From an invitation to Egon Weiner's lecture at the Mezzanine 212 Art Gallery, Palmer House Hotel, Chicago, October 24, 1984, School of the Art Institute of Chicago archive.

[75] From the program for Egon Weiner's 80th birthday celebration by the Crystal Ballroom Concert Association, Blackstone Hotel, Chicago, July 23, 1986, School of the Art Institute of Chicago archive.

[76] Letter to Egon Weiner from Roger Gilmore, dean of the the School of the Art Institute of Chicago, July 6, 1987, School of the Art Institute of Chicago archive.

[77] Letter to the Weiner's family from Roger Gilmore, dean of the School of the Art Institute of Chicago, August 25, 1987, School of the Art Institute of Chicago archive.